IMAGES
of Rail

DETROIT'S STREET RAILWAYS

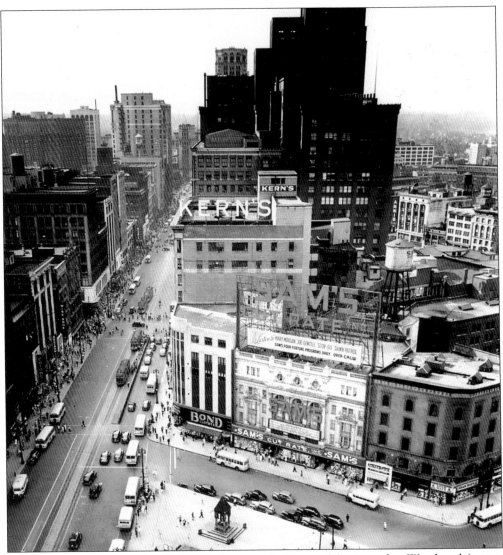

This photograph, taken on June 8, 1939, looks across the Campus Martius and up Woodward Avenue from the National Bank Building. The transformation of downtown Detroit is evidenced by the conversion of the Detroit Opera House into Sam's Cut-Rate. This foreshadowed the much later decline of this once bustling hub of downtown Detroit. The old city hall, demolished in 1961, is just out of the picture to the left, and Hudson's department store, also now demolished, dominates this view of downtown Detroit. The photograph reflects the results of Department of Street Railways general manager Fred Nolan's leadership; with no new streetcars purchased since 1930, the number of busses shown in this photograph clearly outnumber the streetcars in service. (Schramm collection.)

On the cover: Two of the vehicles that Detroit's Department of Street Railways utilized to carry Detroiters during the 1920s and beyond are pictured here. In this April 26, 1925 photograph, there is a Yellow Company manufactured double-deck coach standing alongside a 1924 McGuire-Cummings built DSR Peter Witt No. 3566 on Gratiot Avenue. This photograph was taken to record the beginning of a timed race between the bus and the streetcar to see how long each took to reach their respective downtown Detroit destinations. This competition between bus and streetcar would dominate the Detroit transit scene for the next 30 years. (Schramm collection.)

IMAGES
of Rail

DETROIT'S STREET
RAILWAYS

Kenneth Schramm

ARCADIA

Published by Arcadia Publishing
Charleston SC, Chicago IL, Portsmouth NH, San Francisco CA

Printed in the United States of America

Library of Congress Catalog Card Number: 2005938282

For all general information contact Arcadia Publishing at:
Telephone 843-853-2070
Fax 843-853-0044
E-mail sales@arcadiapublishing.com
For customer service and orders:
Toll-Free 1-888-313-2665

Visit us on the Internet at www.arcadiapublishing.com

CONTENTS

ACKNOWLEDGMENTS

Detroit's Street Railways is a book about the history of public transportation in the Motor City. The cornerstone of this history is the story of the City of Detroit's Department of Street Railways (DSR).

This book is truly dedicated to one individual. That person is none other than my father, Jack Edward Schramm. Affectionately called "Mr. DSR," he is considered the expert on Detroit's transit history. He was the first recipient of the local transit award for his support of public transportation in Detroit and Southeastern Michigan: the Jack Schramm Transit Award. A career DSR employee and an official City of Detroit historian, and co-author of six books on the history of streetcar and interurban railways in southeastern Michigan, Jack has also authored several magazine articles on the history of Detroit's city and suburban bus companies.

Thank you Dad, for all your hard work and dedication. This book was only possible through your many years of hard work and your labor of love in preserving the history of the DSR and the city's transit history dating back to 1863.

I also want to acknowledge and say thanks to the organizations and individuals who assisted me with this book. This includes in particular the Burton Historical Collection at the Detroit Public Library, especially its current and past directors, Mark Patrick, coordinator for special collections, and Dave Poremba, manager, of the Burton Historical Collection, as well as their dedicated staff. I also owe Prof. B. Henning a deep debt of gratitude for all his hard work and long hours spent copying these photographs that we are now able to enjoy in this book.

I also wish to acknowledge the Detroit area rail buffs and "juice fans," whose dedication and true love of the hobby provided many fine photographs and the history behind them. By taking the time to record these scenes of history we can fully appreciate the impressive transit system that Detroiters once enjoyed. This is especially evident as we commemorate the 50th anniversary of the end of streetcar service here in Detroit on April 8, 2006. It was exactly 50 years ago that the last DSR streetcar ran on Woodward Avenue in the Motor City on April 8, 1956, ending a form of public transportation that began with horse-drawn streetcars in 1863.

I also wish to acknowledge and thank the many employees of the DSR who helped my father preserve its very proud history. I especially would like to acknowledge the last general manager of the DSR, the late Ernie Knox, who was my father's protégé, and who himself worked for 50 years rising from working on the DSR money truck to its most senior position as general manager. Thanks too, to another DSR general manager in the 1960s, Robert Toohey. Thanks also go out to Ernie Ryan, the late Harold Rose, Ken Ong, and Jan Kruszewski of the DSR's Plant Maintenance Division; John Zube, Bill Argo, and the late Val Kubiak of intelligence, Ben Virga of research; the late George Gordon of transportation operations; Bill Holmes and Val Fischione of training; Dennis Zawaski of transportation engineering; Robert VanderVoort of vehicle maintenance, and all the many fine DSR employees that made Detroit a mass transit leader in our country. Thank you for helping to preserve the history of the DSR for future generations of Detroiters to enjoy and appreciate.

I especially would like to acknowledge Richard Andrews for sharing many of his DSR pictures used in this book, as well as the many hours he spent at home and away helping to edit this book, but especially for his hard work and his dedication to detail in preparing the many fine maps used in this publication. I also want to thank Tom Dworman for his many photos and editing as well, Val Fischione, Wilbur Hague, Alex Pollock, Ken Homburg, Robert Graham, the late Clarence Faber, Ray Radway, Ray Ryder, Meredith Smith, Howard Ziegel, Richard Fountain, the late Elmer Kremkow, M. D. McCarter, the late Bill Miller, the late Tom VanDegrift, the late George Kuschel, Mike Skinner, and all others who contributed the photographs and facts, stories, and information that made this book possible and this project so very interesting and so very worthwhile. Thank you all.

INTRODUCTION

It was August 4, 1863, in downtown Detroit. A new way of getting about the city was about to be unveiled. Detroit was not yet known as the "Motor City." A new streetcar line built by the Detroit City Railway and operating along East Jefferson Avenue started operating that day, boasting streetcars made of wood and pulled by horses, with only straw on the floor to keep them warm. It ran from downtown to the city limits at Mt. Elliott Avenue. Within a year, three additional horse-drawn streetcar lines were operating along other major streets, including Gratiot, Michigan, and the street that would eventually be considered "main street" in Detroit, Woodward Avenue.

Early Detroit was a boom town with settlers arriving daily. Between 1820 and 1830, the population of the village on the Detroit River increased by 360 percent. A port-of-call for travelers continuing west from the newly completed Erie Canal, which opened to the public in 1825, by 1838 a railroad had begun operating west from Detroit as a part of Michigan's internal improvement program. Near the mid-1840s, the population of the city reached 13,000. Detroit streets became congested with slow moving traffic.

By 1862, Detroit's population had topped 50,000 and the need for expanded public transportation could no longer be ignored. On January 5, 1863, a $5,000 deposit for a franchise was made with the city by a company with financial backers in Syracuse, New York. This group invested $20,000 and sold $100,000 in stocks and $100,000 in bonds locally in order to build a street railway system. The company was named the Detroit City Railway.

The first streetcars were typical of the 16-foot horse cars of that era, with only straw on the floor in winter to keep the cold out. Oil lanterns hung in brackets for interior lighting. The cars had platforms on both ends for entry to the interior through sliding doors. Fares of 5¢ cash or 25 tickets for $1 were charged with no transfer privileges.

By 1870, the city population exceeded 70,000. Route expansions became necessary. A multitude of new streetcar companies came on board, including: the Fort Street and Elmwood Railway in 1865 (renamed the Fort Wayne and Elmwood Railway by the Michigan Legislature in 1871); the Grand River Street Railway in 1868; the Hamtramck Street Railway in 1869; the Central Market, Cass Avenue, and Third Street Railway in 1873; the Detroit and Grand Trunk Junction Street Railway in 1873; the St. Aubin Street Railway in 1873; the Congress and Baker Street Railway in 1875; and others.

As the edge of the city moved outwards with the expanding population, horse car lines tried to keep up, and lines were extended to the new city boundaries. Soon, however, it was impossible to deny that the economical use of the horse was at an end. Detroit needed a faster, cheaper people mover. Various modes of powered transportation were employed, without much success, until electric power was used to propel the streetcar.

The advantages of electric power were numerous: the life expectancy of a horse was very short in street railway service; horses were susceptible to disease; and horse droppings polluted the city streets. Most importantly, though, horses were, relatively, very slow. With the advent of electrical power, a great deal of investment was necessary to transition to the use of the new power source. Power houses, new heavier track, power lines, and new cars required funds amounting to millions of dollars. Many of the horse car line franchises were about to expire and renewals were crucial if the streetcar companies were to secure the heavy investments necessary to implement their conversion from horse-drawn to electric power. Several new electric-powered streetcar lines began operations, including Detroit's first electric system, the Detroit Electric Railway (September 1, 1886), followed shortly by the Highland Park Railway (September 18, 1886). The Detroit Citizens Street Railway came in 1892, followed by the Fort Wayne and Belle Isle Railway in 1893, and the Detroit Railway in 1895.

The conversion to electric power required the consolidation of many of Detroit's smaller streetcar companies. This consolidation continued for over 20 years, culminating in the creation of the Detroit United Railway (DUR) on January 1, 1901. As soon as the DUR had taken control of the city's vast transit operations, the City became interested in taking over the DUR, in order to make it a municipally owned and operated system. Numerous studies were conducted and proposals were placed on the ballots in attempts to persuade the voters to take control of their own transit system. As one transit official stated, "A city transit system that is privately owned usually is placed in an untenable position in that it must give satisfactory service and make sufficient money to cover debts and cost of operation." During this period, very little expansion of streetcar lines occurred. Politicians took shots at DUR fares, equipment, and service. This era culminated in the takeover of the Detroit United Railway and its city operations with the establishment of the City of Detroit's Department of Street Railways (DSR) on May 15, 1922. Detroit was the first city in the United States to establish its own municipally owned transit system. For many years, the DSR was considered the leader in the transit industry, and an innovator in the improvement of transit services for the traveling public.

The DSR expanded and improved the streetcar lines that it inherited from the DUR. It initiated an early electric trolley bus operation in the city and even built an early prototype streetcar and bus in its own shops. The DSR continued to operate streetcar service until April 8, 1956, when the streetcars operated on Woodward Avenue for the last time, replaced by an all-bus fleet. When the DSR started its first coach operations as a separate division in 1925, the purpose of the coaches was to provide feeder service to the established streetcar lines, as the cost of extending streetcar tracks was far too high. Conceived to supplement and expand Detroit's streetcar operations, buses would eventually replace the streetcar as the principal mode of transportation in the Motor City. The DSR itself would disappear on July 1, 1974, when it became the Detroit Department of Transportation (DDOT).

One

EARLY STREETCARS

IN DETROIT

1863–1901

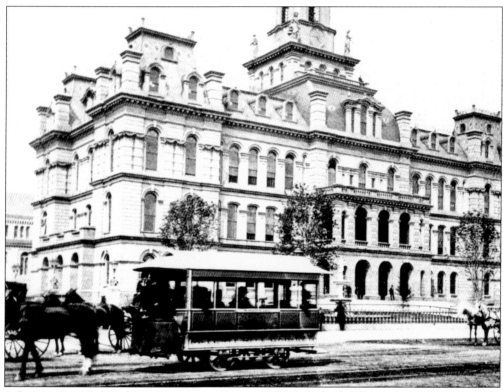

A Detroit City Railway horsecar is passing Detroit's third city hall in this early 1870s photograph. Three streetcar lines were now operating over these tracks, Woodward, Gratiot, and Michigan, all terminating at Jefferson Avenue. This horse-drawn streetcar line started operating on Woodward Avenue on August 3, 1863, eight years prior to the opening of city hall, which itself was dedicated on July 4, 1871. This stately looking city hall replaced a much smaller city hall built in 1835 that was located at Cadillac Square, immediately across Woodward Avenue. Detroit's city hall, pictured here, served the residents of Detroit until the 1950s when a combined City-County Building was built a few blocks away on Woodward, and this building was demolished in 1961 to make room for an underground parking garage. Today a new skyscraper is being built on the site as part of downtown Detroit's revitalization of its Campus Martius. (Burton Historical Collection, Detroit Public Library.)

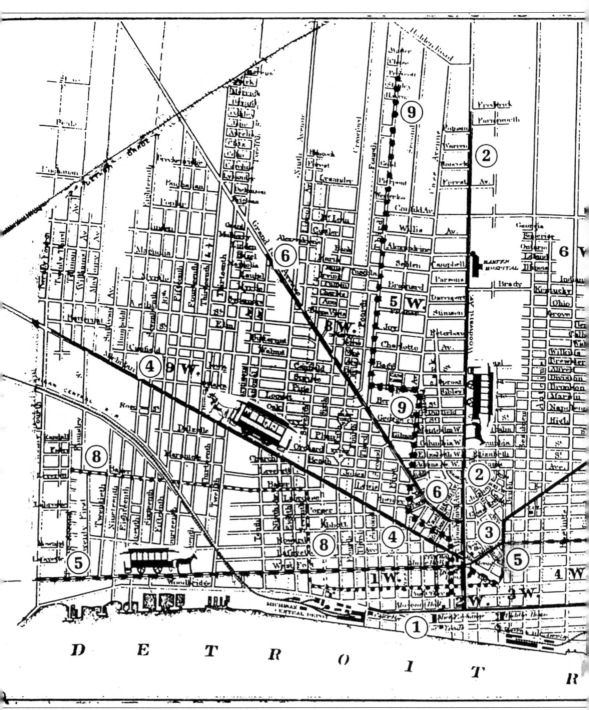

This map appeared in the *Detroit Advertiser* and *Tribune* newspapers, listing the mileage of Detroit's operating horse-drawn streetcar companies and the date when revenue service started for each company. It is one of the earliest maps of Detroit showing the various horse-drawn streetcar companies operating throughout the city in 1874. This includes the very first streetcar line that

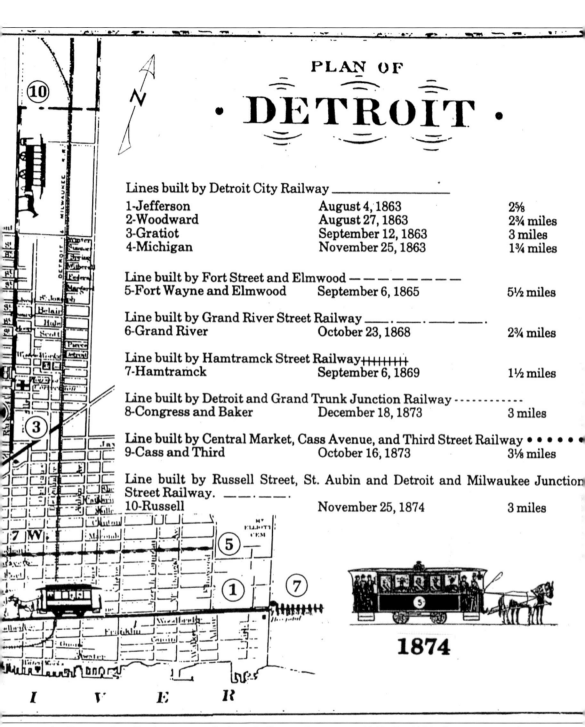

PLAN OF
DETROIT

Lines built by Detroit City Railway _____

1-Jefferson	August 4, 1863	2⅝
2-Woodward	August 27, 1863	2¾ miles
3-Gratiot	September 12, 1863	3 miles
4-Michigan	November 25, 1863	1¾ miles

Line built by Fort Street and Elmwood — — — — — — —
5-Fort Wayne and Elmwood	September 6, 1865	5½ miles

Line built by Grand River Street Railway ___ . ___ . ___ ___ .
6-Grand River	October 23, 1868	2¾ miles

Line built by Hamtramck Street Railway++++++++
7-Hamtramck	September 6, 1869	1½ miles

Line built by Detroit and Grand Trunk Junction Railway - - - - - - - - - - -
8-Congress and Baker	December 18, 1873	3 miles

Line built by Central Market, Cass Avenue, and Third Street Railway • • • • • •
9-Cass and Third	October 16, 1873	3⅛ miles

Line built by Russell Street, St. Aubin and Detroit and Milwaukee Junction Street Railway. ___ . ___ .
10-Russell	November 25, 1874	3 miles

1874

the Detroit City Railway opened along Jefferson Avenue in 1863. By 1874, there were no fewer than seven streetcar companies operating over 10 lines throughout Detroit. The leading streetcar company was the Detroit City Railway, which boasted four horsecar lines operating by 1874.

Detroit City Railway horsecar 4 is heading out Michigan Avenue approaching Third Street. The photograph is undated; however, the wooden sidewalks date it as very early. To protect pedestrians, horses were required to have horsecar bells attached to warn them of the car's approach. (Burton Historical Collection, Detroit Public Library.)

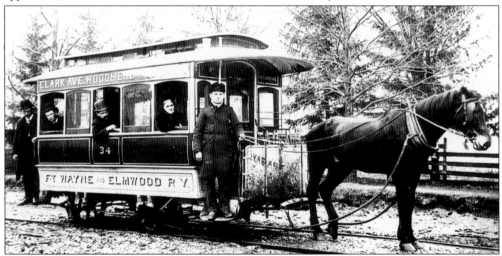

The Fort Street and Elmwood Railway had its name changed in 1871 by the State of Michigan legislature to the Fort Wayne and Elmwood Railway. Seen here is Fort Wayne and Elmwood Railway horse-drawn car No. 34 on a cold winter's day on River Road (now West Jefferson Avenue) near Livernois Avenue. The passengers must have been a hardy lot, having some of the car windows open. The Fort Wayne and Elmwood, one of Detroit's earliest horsecar lines, started operations over the Fort Wayne to Woodward Avenue portion of the line on September 6, 1865, and over the Woodward to Elmwood Cemetery portion on September 19, 1866, a total distance of 12.5 miles. This company boasted of having six horsecars, 70 horses, and 25 employees. (Burton Historical Collection, Detroit Public Library.)

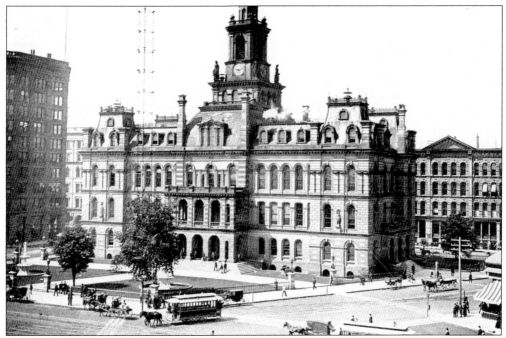

Detroit's city hall was dedicated on July 4, 1871, located on Woodward Avenue between Michigan Avenue and Fort Street. It quickly became the center of attraction, as evidenced in this 1892 photograph. Both open and closed horsecars are evident here shortly before electric cars started operating in the downtown area. A Detroit City Railway car is heading south to Jefferson Avenue. (Schramm collection.)

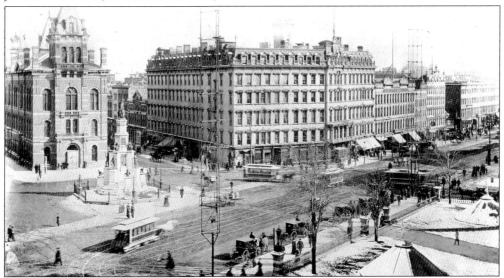

This early photograph of Woodward Avenue in front of Detroit's city hall shows various horse-drawn streetcars. During the 1880s, Detroit's population topped 116,000 residents. The Russell House, across Woodward Avenue from city hall, was Detroit's premier hotel and ready to handle the city's visitors as Detroit became a leading industrial city in the country. The building on the left of the picture is the Central Market, which opened on September 11, 1880. The upper floors of this building contained city offices and courts. (Schramm collection.)

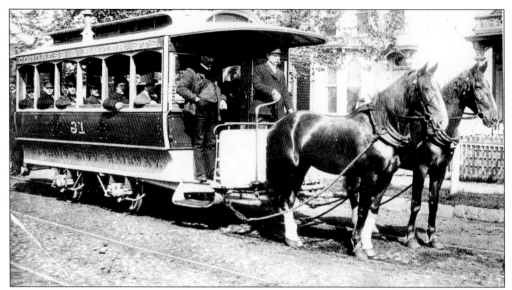

Car 81 of the Congress and Baker line of the Detroit City Railway started from Woodward Avenue and Congress Street, and ended at Livernois and Dix Avenues. The photograph was taken in Detroit's Irish "Corktown" neighborhood sometime after 1885 when the line was later taken over by the Detroit City Railway. The reason for the photograph was to show the stovepipe in the roof, showing that a stove had been installed in the car to replace the straw on the floor of this horsecar, which up to this time was the only means of keeping out the cold during the winter months. (DSR files.)

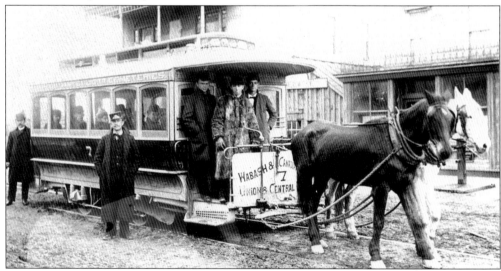

The exact location and date of this early photograph of horsecar No. 7 of the Fort Wayne and Elmwood Railway are unknown. The heavy coats on the passengers and crew indicate a cold day in winter. The west terminus, Fort Wayne, is a historic fort built during the 1840s, originally built to protect Detroit from an invasion from Canada. Used during the Civil War and an active army garrison until the early 1970s, it still stands today as a museum for the City of Detroit. The east side of this line ended at the historic Elmwood Cemetery, where many of Detroit's business and political leaders are buried. A round-trip over this 12.5-mile-long horse-drawn streetcar line took 170 minutes, or just under 3 hours, when it opened in the 1860s. (Alex Pollock.)

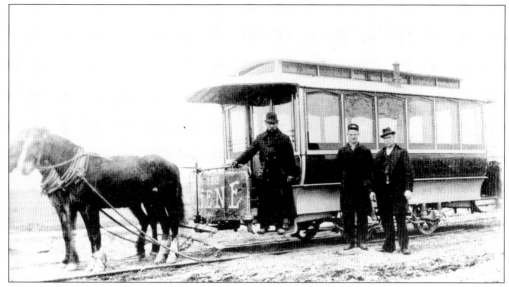

A Chene horsecar is pictured with crew on a cold winter's day. The Chene streetcar line was built by the Detroit City Railway and began operating on August 3, 1889. It was the last horsecar line in the city to be converted to electric. Here is car 202; the man wearing the derby is the conductor, who could go inside the car and be protected from the weather while the driver had to weather the elements. (Schramm collection.)

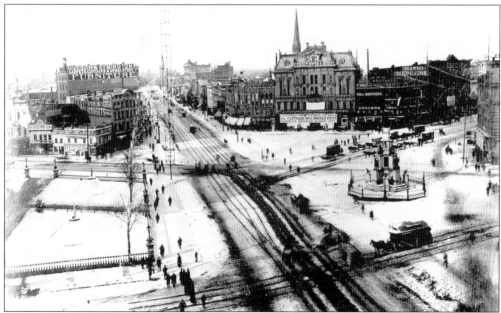

Set against a winter wonderland scene in downtown Detroit, this photograph highlights the four streetcar tracks that once traversed Woodward Avenue in front of Detroit's city hall. By 1883, the Grand River Railway franchise had been amended to allow four tracks on Woodward from Grand River Avenue to Fort Street. This track arrangement included the use of both standard (four feet eight and a half inches) and narrow-gauge (four feet seven inches) tracks. Note the light tower in front of city hall in this winter scene. The cluster of arc lights atop the towers did not operate on moon-lit nights. (Schramm collection.)

Taken in 1892, a westbound horse-drawn streetcar on Fort Street, bound for Fort Wayne, has just crossed Woodward Avenue. The streetcar's competition, Hanson Cabs, are parked in front of and along the side of Detroit's city hall, located on the left of this photograph. During the following year, this line would be electrified. (Schramm collection.)

Fort Wayne and Elmwood car No. 22 is photographed in front of Detroit's David Scotten Building. This building was built in 1875 at Fort and Campau (Scotten) Streets by David Scotten, who was a leading dealer in tobacco. He operated the business under the Hiawatha Tobacco Company name. Detroit, at this time, was a leader in the chewing tobacco and cigar industry. (Schramm collection.)

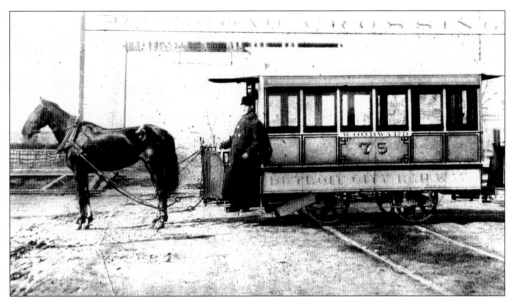

Detroit City Railway horse-drawn streetcar 75 is on the turntable changing its direction of travel. The Woodward horsecar line was extended, by 1879, to the Michigan Central Railroad's Bay City Branch (Baltimore Avenue) crossing. This photograph shows the rural appearance of the area, which is just a few blocks from the recent world headquarters of the General Motors Corporation, now current offices for the State of Michigan at Cadillac Place. (Burton Historical Collection, Detroit Public Library.)

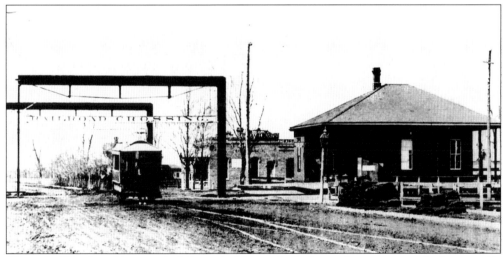

When the Woodward line reached the end of the track, the horse-drawn streetcar had a turntable to reverse its direction of travel. Passengers could either board the steam train or cross the tracks to the waiting room of the Highland Park Railway electric cars to continue their journey north to the village of Highland Park. In later years, this was a very active station for the Michigan Central (New York Central) where passengers could board the northbound "Timberliner" and travel to Mackinaw City and other northern Michigan destinations. Today the station is gone; however, Detroit's Amtrak train station is located nearby. (Burton Historical Collection, Detroit Public Library.)

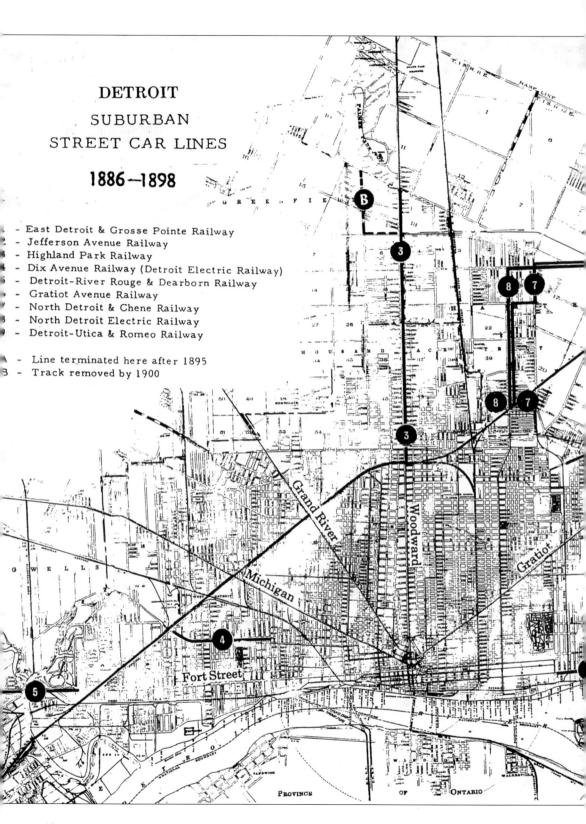

DETROIT
SUBURBAN
STREET CAR LINES

1886—1898

- East Detroit & Grosse Pointe Railway
- Jefferson Avenue Railway
- Highland Park Railway
- Dix Avenue Railway (Detroit Electric Railway)
- Detroit-River Rouge & Dearborn Railway
- Gratiot Avenue Railway
- North Detroit & Chene Railway
- North Detroit Electric Railway
- Detroit-Utica & Romeo Railway

A - Line terminated here after 1895
B - Track removed by 1900

18

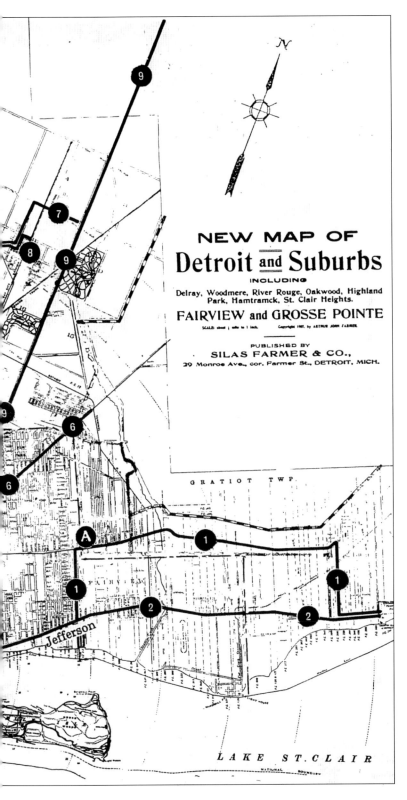

NEW MAP OF
Detroit <u>and</u> Suburbs

INCLUDING

Delray, Woodmere, River Rouge, Oakwood, Highland
Park, Hamtramck, St. Clair Heights.

FAIRVIEW and GROSSE POINTE

SCALE about ⅓ mile to 1 inch. Copyright 1907, by ARTHUR JOHN FARMER.

PUBLISHED BY

SILAS FARMER & CO.,

29 Monroe Ave., cor. Farmer St., DETROIT, MICH.

G R A T I O T T W P.

Jefferson

L A K E S T. C L A I R

NATIONAL BOUNDARY

This map highlights the growth of not only the city of Detroit, with its expanding population and the increasing need for streetcar lines, but the expansion of what was then considered Detroit's suburbs. Shown are the several streetcar companies that offered services beyond the then city limits. This was a period of expansion in terms of not only the area where streetcars were operating, but it was also the period of improved streetcar technology with the conversion of horse-drawn streetcars to those powered by steam and electricity.

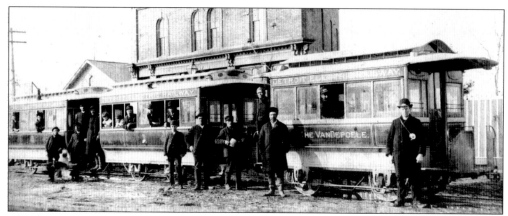

The first day of operation of the Detroit Electric Railway on Dix Avenue signaled the first electric operation in the Detroit area. It featured the electric system developed by Charles J. Van Depoele. Van Depoele, an immigrant from Belgium, settled in Detroit in 1874 and continued experimenting with electric machines. He is credited with lighting Most Holy Trinity Church on Christmas Eve 1879, which is reported as the first public building lighted by electricity in the United States. He was later able to interest several cities in his electric streetcar, and Windsor, Ontario, was the first to purchase the Van Depoele system in the Detroit area. The first electric car in Windsor began operating on June 6, 1886. This construction inspired Detroiters to promote a line on Dix Avenue (Vernor) from Twenty-fourth Street to the city limits at Livernois Avenue and beyond that opened for service on September 1, 1886, as shown in this photograph on opening day. Power was supplied by the Michigan Central Railroad shops on Livernois Avenue. (Schramm collection.)

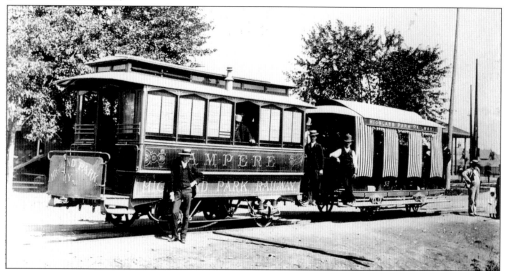

The Detroit area's second electric street railway company, the Highland Park Railway, started operations on September 18, 1886. Here the "Ampere" pulls a trailer along the three-mile route between Detroit and Highland Park using the Fisher System. Instead of using the traditional overhead wires, this system called for a slotted third rail. It ran on Woodward Avenue from the Bay City crossing, where the Detroit City Railway horsecar ended up, to Highland Park, ending at a street called Manchester. Later the line was converted to a regular trolley system and became part of the Woodward line, the last streetcar line to operate in Detroit. (Burton Historical Collection, Detroit Public Library.)

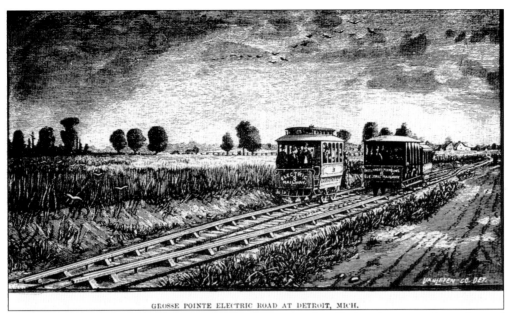

GROSSE POINTE ELECTRIC ROAD AT DETROIT, MICH.

The East Detroit and Grosse Pointe Railway was completed in 1888 with its powerhouse located at Mack and Conner Avenues. Its cars operated on the Fisher "slotted third rail" system. The route was from Water Works Park on Jefferson Avenue, on to Cadillac Avenue, then Mack Avenue, St. Clair Street (in Grosse Pointe) back to Jefferson and Fisher Road. Later the railway switched to the Healy Steam Motor and then, finally, electric trolley overhead. (Schramm collection.)

A very early Healy Steam Motor is advertised here. In Detroit, the Healy Steam Motor operated on several routes, which included the Jefferson Avenue Railway, East Detroit and Grosse Pointe Railway, North Detroit, and the Grand River Railway, beyond the city limits. Unfortunately, future planned expansions stopped when C. E. Healy drowned in a boating accident. (Schramm collection.)

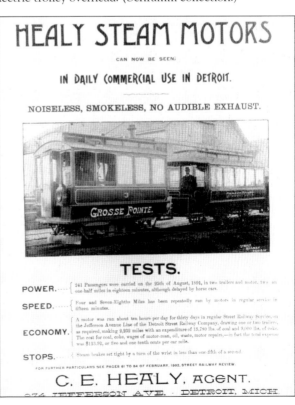

HEALY STEAM MOTORS

CAN NOW BE SEEN

IN DAILY COMMERCIAL USE IN DETROIT.

NOISELESS, SMOKELESS, NO AUDIBLE EXHAUST.

TESTS.

POWER.····{ 241 Passengers were carried on the 25th of August, 1891, in two trailers and motor, two and one-half miles in eighteen minutes, although delayed by horse cars.

SPEED.····{ Four and Seven-Eighths Miles has been repeatedly run by motors in regular service in fifteen minutes.

ECONOMY.{ A motor was run about ten hours per day for thirty days in regular Street Railway Service, on the Jefferson Avenue Line of the Detroit Street Railway Company, drawing one or two trailers, as required, making 2,232 miles with an expenditure of 15,780 lbs. of coal and 9,000 lbs. of coke. The cost for coal, coke, wages of motor-man, oil, waste, motor repairs,—in fact the total expense was $113.92, or five and one-tenth cents per car mile.

STOPS.····{ Steam brakes set tight by a turn of the wrist in less than one-fifth of a second.

FOR FURTHER PARTICULARS SEE PAGES 61 TO 84 OF FEBRUARY, 1892, STREET RAILWAY REVIEW.

C. E. HEALY, AGENT.

974 JEFFERSON AVE. DETROIT, MICH.

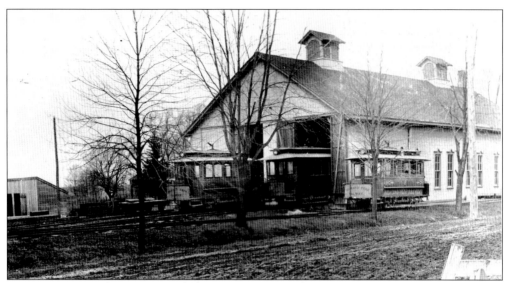

This scene shows three Highland Park Railway cars and the company's two-track carbarn located in Highland Park. Little more information has been found about this photograph and the one below, both of which were found some years ago in the local historical museum in Wayne, Michigan. (Richard Andrews collection.)

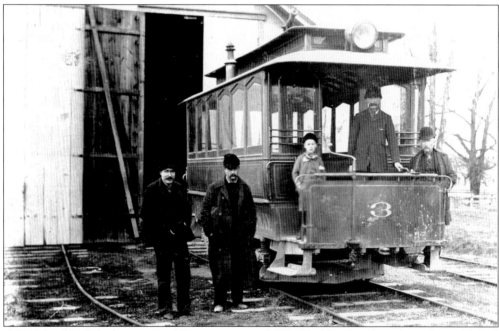

A Highland Park Railway car and barn are pictured. The Highland Park Railway also published a real estate promotional booklet highlighting its many fine services. It opened a three-mile-long line on October 1, 1886. The fare was 5¢; by arrangement with the city railway, 8¢ paid the fare on both the electric and the Woodward Avenue lines. It converted from the Fisher third-rail system to the electric overhead system around 1890. This photograph was taken after the conversion at the Highland Park Railway's carbarn on Glendale Street in Highland Park. (Richard Andrews collection.)

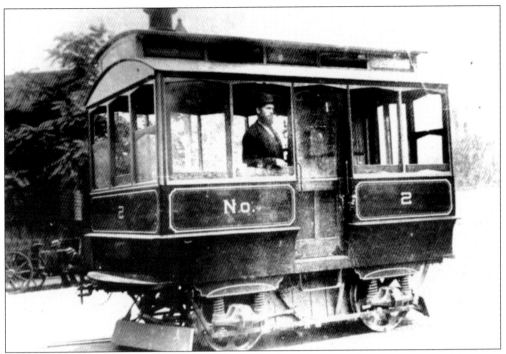

Seen here is a Healy Steam Motor with C. E. Healy at the controls demonstrating his power unit. Passengers could not ride in the power unit, but rather in the trailers following. The charter granting the streetcar company these rights also allowed the company to carry freight and mail to post offices along the route. This was metropolitan Detroit's fourth suburban streetcar operation that served Grosse Pointe as well as Detroit's east side. (Schramm collection.)

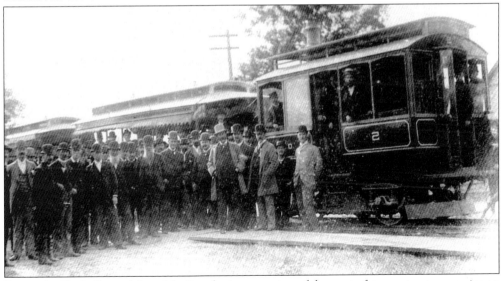

Pictured is Healy Steam Motor No. 2 at the inauguration of the start of steam streetcar service on the Jefferson Avenue Railway Company on September 7, 1891. The distinguished looking man gazing out the window was C. E. Healy himself, the inventor of this motorcar. This company had a charter from the City of Grosse Pointe dated March 13, 1881. The route was from Water Works Park in Detroit to Fisher Road in Grosse Pointe. (Schramm collection.)

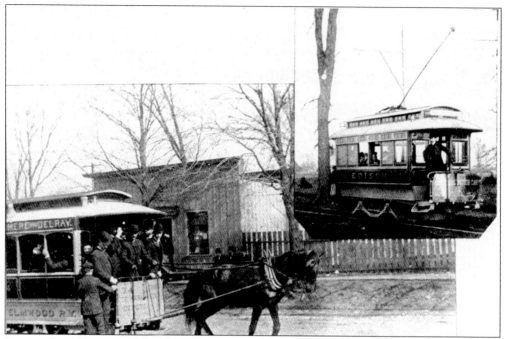

Detroit, River Rouge and Dearborn electric streetcar scenes are seen here as shown in one of the company's promotional brochures. The company published a booklet in 1891 with these and many other Detroit area scenes. Its development was along Oakwood Boulevard, and its route was on Fort Street from Woodmere Cemetery at Dearborn Street, across the Rouge River, then west along Oakwood Boulevard. It started operations in January 1892 and was taken over by the Fort Wayne and Belle Isle Railway in 1893. The fare was 1¢ each way. (Schramm collection.)

Detroit, River Rouge and Dearborn Street Railway is showing its powerhouse and carbarn. This was located on Fort Street just west of the Rouge River. The carbarn was a former fire station that had been converted to a power station and a car house. This view looks east on Oakwood Boulevard toward the Rouge River. The carbarn still stands today as a local saloon. The streetcar is shown about to cross the bridge over the Rouge River. This company's promotional booklet compared its electric cars with the Fort Wayne and Elmwood Street Railway horse-drawn cars since each line connected at Woodmere Cemetery. (Schramm collection.)

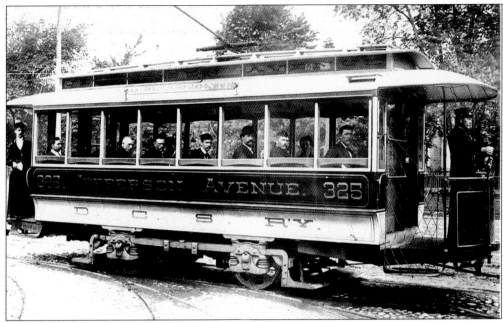

When the Detroit Citizens Street Railway decided to change over to electrical operations on Jefferson Avenue, it ordered larger cars. Shown here is a Brownell Car Company of St. Louis streetcar No. 325 along Jefferson Avenue posing for a photograph in front of the Jefferson car house located near the Belle Isle Bridge. Five cars were purchased in 1893 for the Jefferson line. They were originally numbered 323–327 and, later, renumbered 436–440. By 1909, they were all double-ended. The last car of this series that was still operating in Flint, Michigan, No. 438, later ended up as a shelter on the Stephenson line on December 28, 1921, and was used until this line ended service on May 31, 1934. (Schramm collection.)

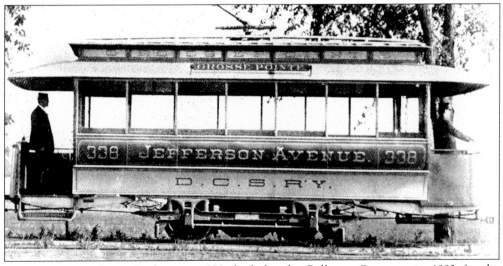

Detroit Citizens Street Railway car 338, built by the Pullman Company in 1893 for the Woodward line, was equipped with a Detroit Electrical Works system. This photograph shows car 338 passing Detroit's Water Works Park, heading out Jefferson Avenue on its way to Grosse Pointe. (Schramm collection.)

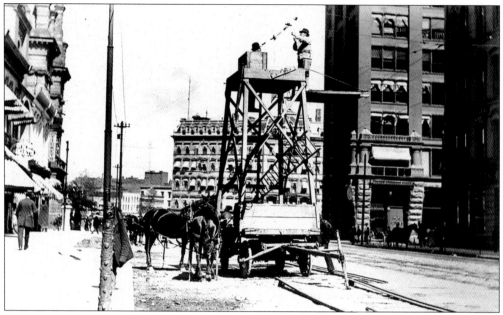

Installing the overhead meant installing wires and bonding the track. Shown here at Griswold and Fort Streets, on the Fort Wayne and Belle Isle Street Railway line, horses were used to pull a custom-made tower wagon. Metal span wire poles were used in the downtown area, while wooden octagon poles were popular elsewhere on the system. (Burton Historical Collection, Detroit Public Library.)

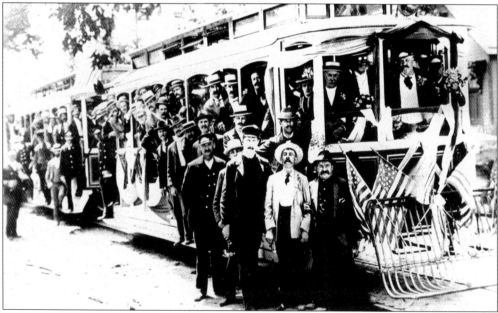

Detroit's Mayor Hazen Pingree, shown here in the center window, is operating a specially decorated Detroit Railway open-bench car on the first day of operation on July 8, 1895, over the Crosstown and Belle Isle lines. Detroit now had three operating streetcar companies. These were commonly referred to as the "3¢ lines" or the "Pingree lines." On July 29, 1896, the Detroit Railway was sold to the Detroit Electric Railway. (Schramm collection.)

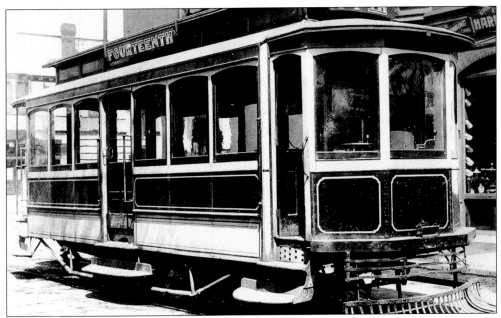

Detroit Railway's streetcar No. 181 is underway along the Fourteenth Street line. This car was part of Detroit Railway's second car order for 27 streetcars that was placed with the Kuhlman Car Company. Originally numbered 77–103, they were later renumbered 177–203. Streetcar 181 is shown here after this renumbering and using a stove, replacing the original electric heaters to reduce costs. (Clarence Faber collection.)

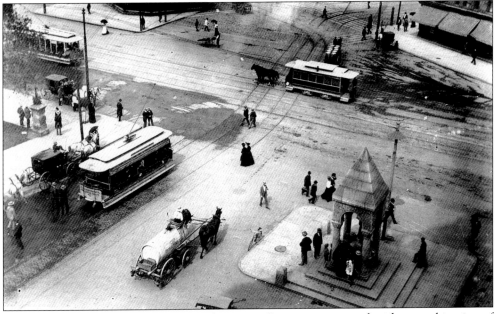

Woodward Avenue and Fort Street in downtown Detroit are pictured with a combination of horse-drawn streetcars and electrics. Open-bench electric car 41 of the Fort Wayne line heads west on Fort Street, while heading north on Woodward Avenue is a Detroit Citizens horsecar that is about to pass a Woodward open-bench electric car. The horse-drawn wagon with tank heads east on Fort Street, probably delivering water to homes along the route. (Schramm collection.)

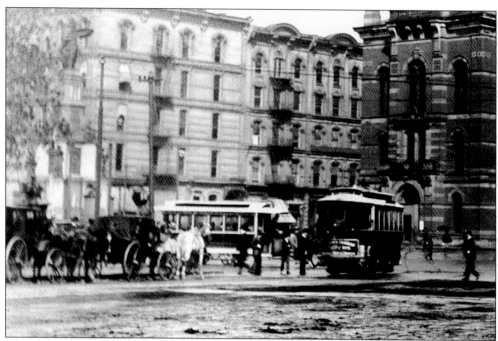

Campus Martius in downtown Detroit is pictured with a Fort Wayne and Elmwood Railway electric car on its single line. It was the first all-electric streetcar operation in the city. (Schramm collection.)

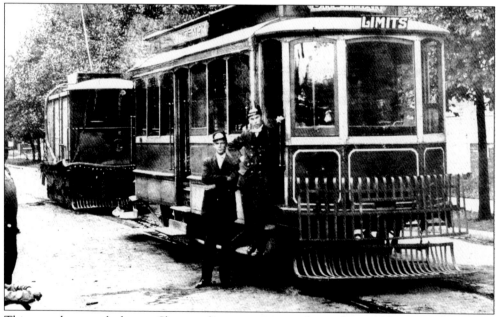

This rare photograph shows a Sherman line car waiting in front of a sprinkling car. This service by the railway company was ordered in the franchise agreement between the City of Detroit and the streetcar companies. It was needed to settle the dust when faster electric cars operated over the dirt streets. It was finally discontinued when the Department of Street Railways (DSR) took over. (Schramm collection.)

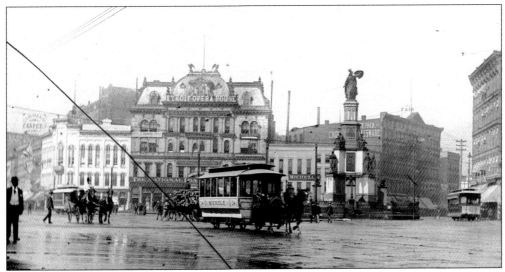

Detroit Citizens Street Railway horsecar No. 24, on the Myrtle line, is passing by Detroit's Soldiers and Sailors Monument on Woodward Avenue in downtown Detroit. Myrtle was one of the last horsecar lines electrified. The Myrtle line started operations on June 25, 1886, and was one and one-fourth miles long. It took 70 minutes to complete the round-trip. The other two streetcars shown, one to the left on Woodward and one to the right crossing Campus Martius, are electric cars. The Detroit United Railway tried for many years to connect it with the Mack Avenue line in an attempt to create a functional crosstown line. All that remains in this picture today in downtown Detroit is the monument. (Schramm collection.)

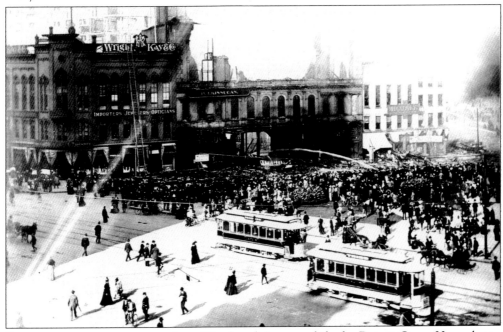

Streetcars continue to operate along Woodward Avenue while the Detroit Opera House burns on October 7, 1897. The photograph shows streetcar 367 being passed by 353. The opera house was later rebuilt with one of its tenants being J. L. Hudson's department store and, in later years, Sam's Cut-Rate department store. (Burton Historical Collection, Detroit Public Library.)

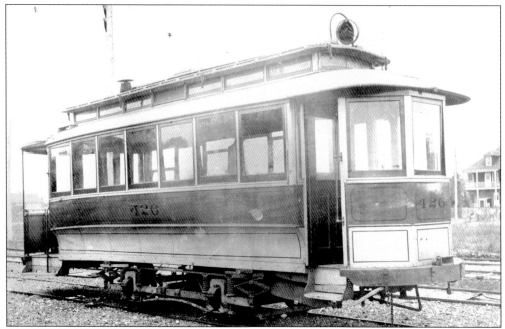

Car 426 was built by Pullman in 1893. It may be a part of the third order of cars ordered by the Detroit Citizens Street Railway. The cars in this order were numbered 328–339 and later renumbered 426–435. By the mid-1890s, the front platform was enclosed, by the order of the City. (Schramm collection.)

Taken after June 27, 1887, when the Fort Wayne and Elmwood Railway was extended from Elmwood to the East Grand Boulevard on Elmwood Street and Champlain Street (Lafayette). This line was still Detroit's only crosstown streetcar operation. Note the large photograph of Ulysses S. Grant surrounded by flags. The city was preparing to honor the former United States president and to commemorate the Grand Army of the Republic's 25th anniversary. (Schramm collection.)

Two

Detroit United Railway and the City of Detroit Municipal Operations

1901–1922

A 1902 photograph shows car 266 in front of the Detroit United Railway (DUR) shops. The first cars built were 124 single-truck cars, 34 feet 9 inches in length, which carried 29 passengers. The DUR used numbers open at the time, 51–75, 176, 204–242, 247–271, 300, and 392–400. The cars even carried a plaque that read "Built at Company's Shops." (Schramm collection.)

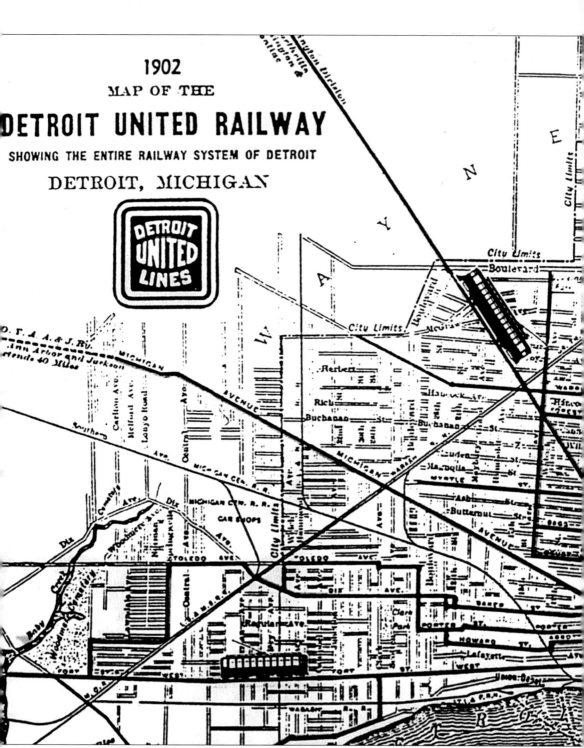

1902
MAP OF THE
DETROIT UNITED RAILWAY
SHOWING THE ENTIRE RAILWAY SYSTEM OF DETROIT
DETROIT, MICHIGAN

Seen here is a system map of the Detroit United Railway (DUR) in 1902 that includes all its city services, as well as its suburban lines radiating from Detroit. It was the consolidation of several city streetcar companies on January 1, 1901, that led to the formation of the Detroit United Railway (DUR). The DUR would immediately start purchasing various interurban railways that

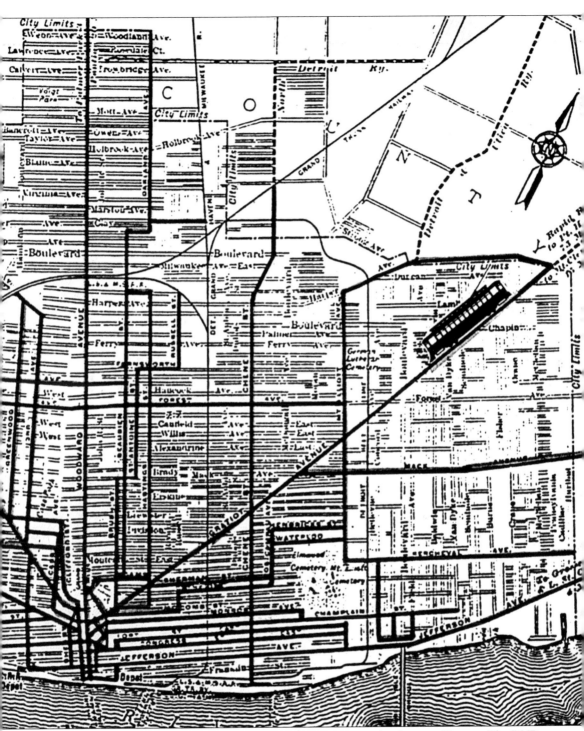

would become a major transportation system in the Detroit area for the next 30 years. The DUR covered several hundred miles of track, hundreds of passenger and freight cars, and thousands of employees. It remained operating over various divisions until 1928, and with the subsequent Eastern Michigan System until 1934.

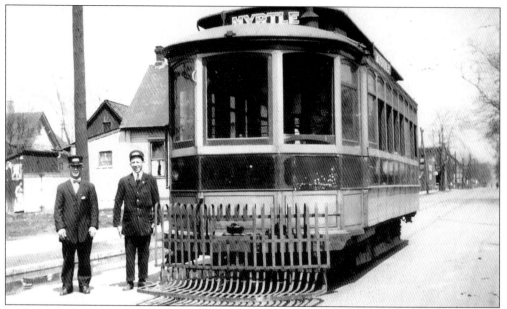

After moving to its new shops on Monroe Street, the DUR built its second group of closed cars, 1250–1261 in 1905 and 1262–1273 in 1906. These cars were similar in appearance and dimensions, except they seated one more passenger on their cross seats with their side aisle and had eight windows instead of seven. There is no record of these cars being converted to pay-as-you-enter fare collection. (Schramm collection.)

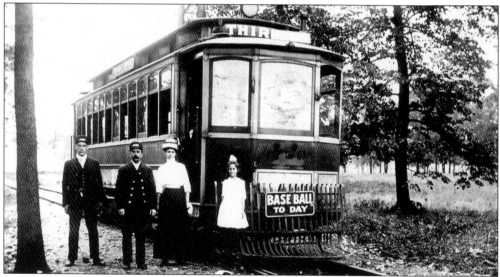

A popular pastime in Detroit was taking the trolley to a local baseball game. Here the streetcar's motorman and conductor, dressed in their finest uniforms, pose for a picture with some of Detroit's prettier and more fashionable baseball fans. This streetcar is laying over at the end of the Hamilton line at Webb Avenue in 1912. The sign on the top of the streetcar says "Third." The reason for this identification sign on the streetcar was because the line operated southbound on Third Street between Holden Street and Grand River Avenue. The sign at the front of the streetcar advertises "baseball today," which was the popular sport of the day. It looks like all four people, including the motorman and conductor, will be heading for the ballpark. (Tom Dworman collection.)

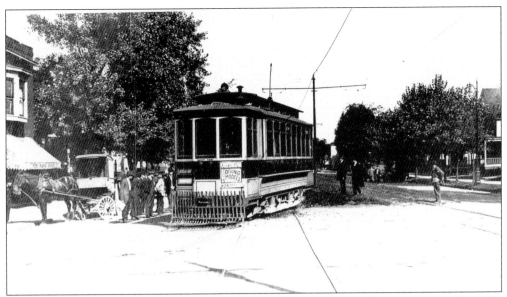

This derailment occurred on the Crosstown line on Warren Avenue. This track was built by the Detroit Railway. Having to operate these single-truck cars on open tracks added to the problem leading to numerous derailments. These single truck cars operated much better on rigid tracks in city pavement. The Detroit United Railway was forced to purchase these 900 series small cars. (Schramm collection.)

Here a "dinkey" on the Myrtle line takes on air. The memorandum on the back of this picture reads, "Dinkey, side collect car, aisles on avenue (right side) only, reach in for fare, taking on air, Dad Reed, Trumbull Car House, Myrtle Line - 1918." The Detroit United Railway was an early user of the Magnum storage air system, and, thus, the DSR had to install compressors on hundreds of cars. The Municipal Operations and the DSR built streetcar lines that had no provisions for recharging air tanks. (DSR files.)

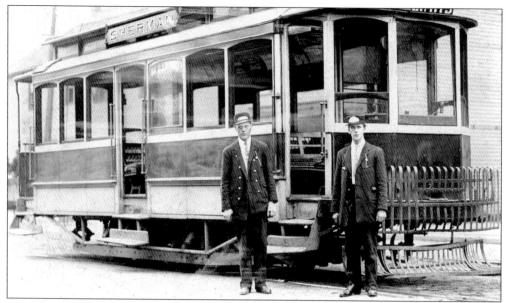

This photograph shows a Kuhlman car in service on the Sherman line. These cars were fast, carried a heavy load, and used on the Pingree lines with their sharp curves. In 1912, these cars were replaced by the 850–999 series cars, which were also single truckers. The reason for this was that these older cars could not be converted to pay-as-you-enter operations. These cars had two fare boxes, one for cash fares, the second one for tickets. The center door was controlled from the rear platform. (Schramm collection.)

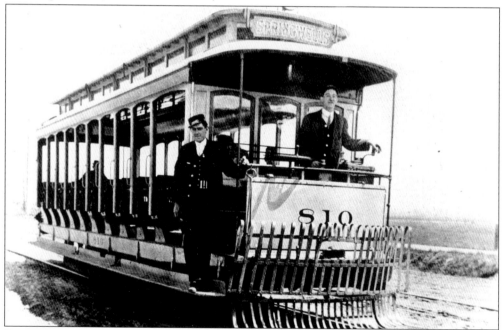

Detroit United Railway open-bench car 810 is at Springwells. This is part of a group of cars built by the Detroit Citizens Street Railway, numbered 788–810. Many of these ended up as trailers in later years. The DSR, however, did not obtain any of these series trailers from the Detroit United Railway in its 1922 purchase. (Schramm collection.)

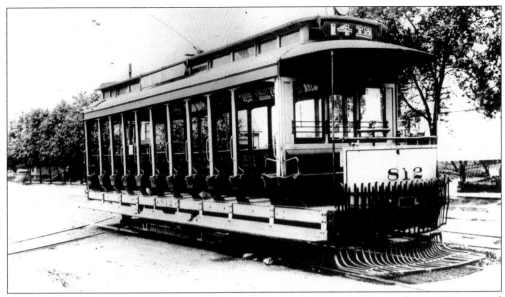

Detroit United Railway open-bench car 812 poses on the Fourteenth Street line at Warren and Lawton Avenues. This car was part of a group of cars built by the Detroit United Railway in its shops, car numbers 811–825. In later years, many were converted to trailers. These were the last open bench cars obtained for Detroit. (Schramm collection.)

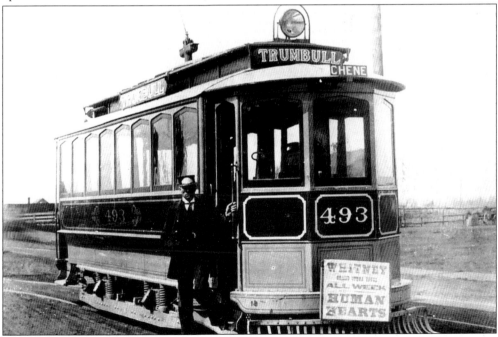

Car 493 lays over at the end of the Trumbull line near West Grand Boulevard. This car was built in 1895 and carried 25 passengers. By May 15, 1922, the Trumbull line had been extended to Fenkell Road and Washburn Avenue; part of this extension was built by the city's Municipal Operation. Later the line would be extended to Birwood Avenue. The wye at the end of the line at Birwood was one of the two wyes where the car went in forward and then backed out. (Val Fischione collection.)

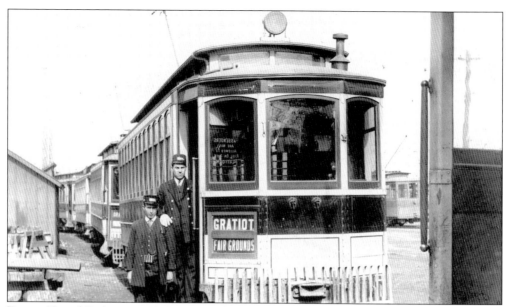

Detroit United Railway car 1640 is pictured with a motorman and conductor in the yard. This car was part of an order received in 1910. Built by the Niles Car Company, it was a double-truck car that could seat 45 passengers. In 1922, the car went to the city's Department of Street Railways. Roof mounted headlights, as seen in this photograph, was characteristic of the DUR's city operated cars. The DSR followed this practice as well until the 1920s, when they relocated the headlights to the front dash so a ladder was not required for headlight lamp replacement. An exception were the Birneys which retained their roof-mounted headlights. (Schramm collection.)

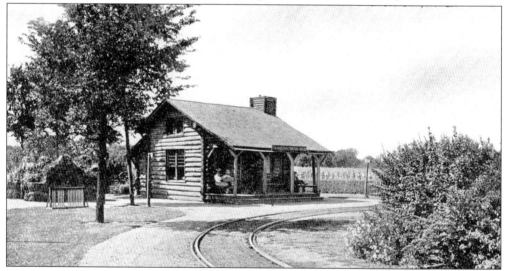

This was the DUR's waiting room in Palmer Park, also known as Log Cabin Park. This was due to United States senator Thomas W. Palmer having built himself a large log cabin here to get out of Detroit for restful weekends. His log cabin still exists but is closed to the public. The DUR demolished this waiting room when it widened Woodward Avenue around the 1930s. Senator Palmer donated his cabin and the land to the city, creating what is today called Palmer Park, which is located between Six Mile Road and Seven Mile Road, west of Woodward Avenue. (Schramm collection.)

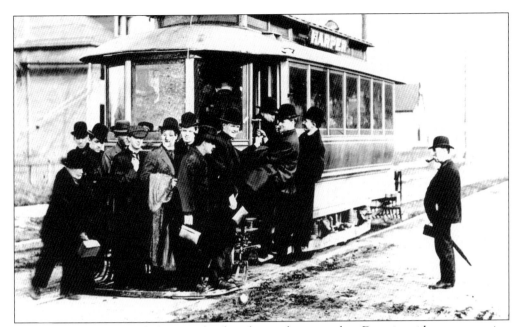

This was probably a posed photograph taken during the years when Detroit residents were voting on whether to purchase the Detroit United Railway. A local Detroit newspaper, the *Detroit News*, liked to print such photographs to show the public the DUR's poor streetcar service. This sort of picture made headlines and sold newspapers. This photograph was taken at Mt. Elliott Avenue and East Grand Boulevard. (DSR files.)

This was one of the Jones Car Company cars and one of the first electric streetcars placed in service on Jefferson Avenue in 1892 by the Detroit Citizens Railway. These cars carried just 21 passengers and were considered too small for city operations. They were later converted to line cars and other work cars. Here is car 95, used as a line car, with the three-man crew posing for the photographer. (DSR files.)

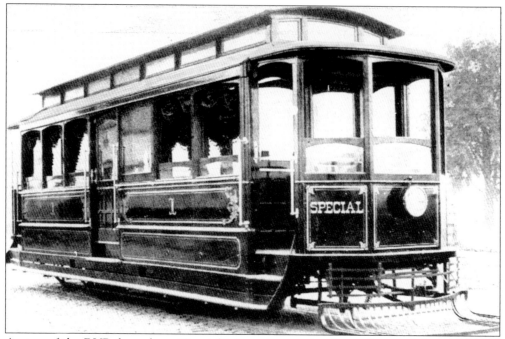

A view of the DUR funeral car "Special" shows its exterior. It was first used for a funeral at Woodmere Cemetery on June 17, 1897, for a Detroit Citizens Street Railway motorman. (Schramm collection.)

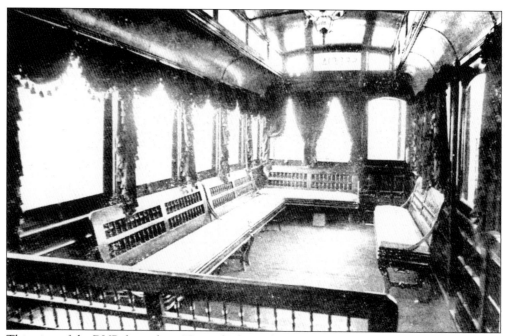

This view of the DUR funeral car "Special" shows the car's interior where the casket was placed and the seats for the mourners. Many of Detroit's cemeteries had sidings located within them so that the funeral cars could pull in and out of the flow of traffic along the electric interurban main line. The funeral car could carry 28 mourners. (Schramm collection.)

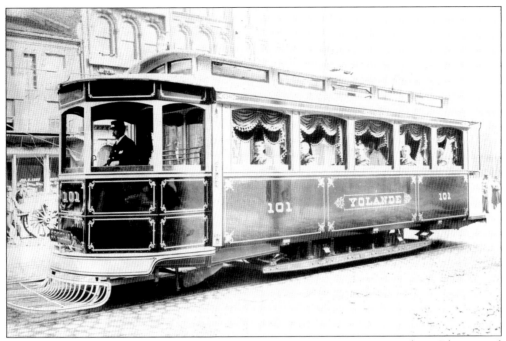

This is the first "Yolande" private car built by the Detroit Citizens Street Railway. This special car was used as a sightseeing car around Detroit. (Schramm collection.)

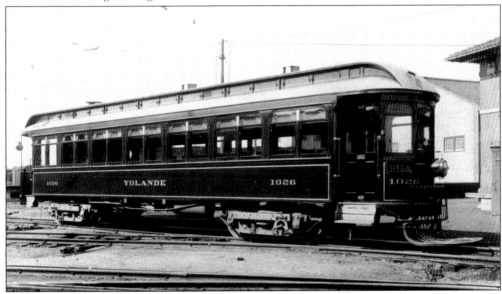

Detroit United Railway private car "Yolande" 1026 operates with a load of passengers—a car with many names but only one purpose. It was first called "Special," then "Tourist," and then it garnered its most famous name, the "Yolande," which was finally replaced with "Ottawa." It began as an excursion car visiting the tourist attractions of Detroit on a circular route that usually lasted two hours. The fare was just 25¢. An attendant with the car explained the points of interest. The last name, "Ottawa," was applied when assigned to the Pontiac to Detroit run for the Eastern Michigan Railway. In 1932, the car was sold to become a roadside diner at Clarkston, Michigan, where it later burned to the ground. (Clarence Faber collection.)

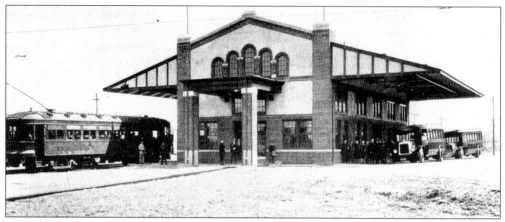

The DUR needed to use city tracks for its interurbans to go downtown, and it was estimated during maximum load periods, 65 cars were tied up in traffic. The interurban cars averaged 9 miles per hour in city traffic; while out in the country, they averaged 36 miles per hour. To alleviate this problem, the DUR planned to build three terminals at the Detroit city limits—one on Gratiot Avenue, the second on Fort Street, and the third in Highland Park along Woodward Avenue. Only the first two of these were built. Passengers would transfer from the interurban cars to buses to complete their trip to downtown and the reverse coming out. The terminals did offer a waiting room complete with a ticket counter and soda fountain. The plan, however, did not work well since the buses that the passengers were transferring from and to were also getting tied up in traffic. From March 19, 1925, to March 7, 1927, no interurban cars were dispatched downtown. After March 7, the interurban cars once again traveled to downtown. The buses used for this experimental service were sold, with the DSR purchasing 41 of them. (Schramm collection.)

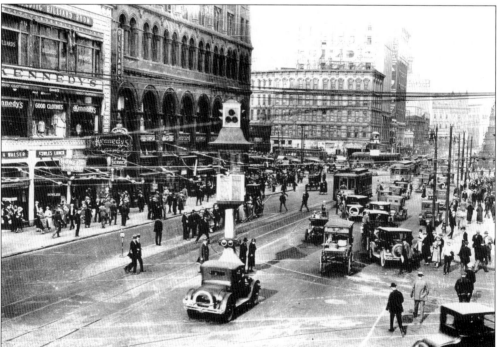

Downtown Detroit on Woodward Avenue shows heavy traffic and a Detroit Police–manned traffic tower. The traffic tower was a predecessor to today's traffic signals. (Schramm collection.)

On April 5, 1920, Detroit citizens voted Mayor James Couzens the funds needed to build the municipal system. Within 24 hours, the mayor appeared before the Detroit press, turning a shovel full of dirt to inaugurate "Big Jim's City Streetcar System." Shown here on August 23, 1920, Mayor James "Big Jim" Couzens drives the first spike on Harper Avenue. (DSR files.)

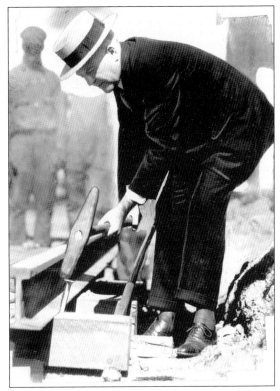

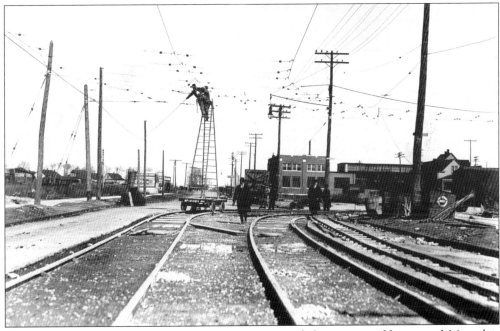

Workers are installing overhead on the city's Municipal Operation at Harper and Montclair Avenues on Detroit's east side on March 16, 1921. Note the small rail-mounted wagon holding the tower. This is the same location where the DSR would later test its trolley busses beginning in 1921. (DSR files.)

Detroit's mayor, James Couzens, who considered himself a transit expert, ordered 250 of these small single-truck Birneys. They were nicknamed "Couzens Cooties." After the delivery of the roomier Peter Witts, Detroiters called them the "Half Witts" and found them uncomfortable to ride with their single trucks. In 1924, 200 were up for sale, and 56 were eventually sold with the rest being scrapped. Many of those remaining were rebuilt from double-end to single-end operations. By 1930, 18 of these converted cars were still in service. Seen here is No. 200 at the DSR Woodward car house. Birneys were used briefly on the Oakman line; however, the eight miles of open track were not suitable for single-truck cars. (Photograph by Elmer Kremkow.)

On Shoemaker Avenue, a lineup of newly delivered Birneys are seen, probably headed for the training track on Montclair between Harper and Shoemaker Avenues as soon as trolley poles and other required hardware was installed. Being a city department, the Municipal Operation just parked them on the street. (DSR files.)

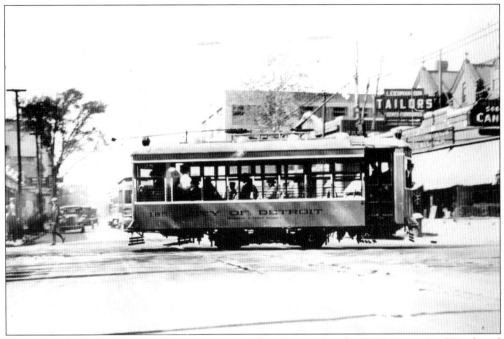

Birney 185, loaded with Detroit's common council out inspecting the DSR, is crossing Woodward Avenue at Davenport Street on August 21, 1921. (DSR files.)

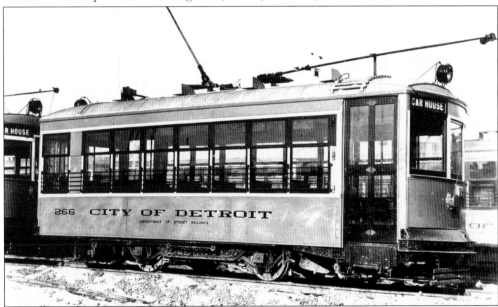

DSR Birney 266 is shown here in the yard. Birneys were supplied by various builders from a patent held by Charles O. Birney, but each company had its own individual subtle differences built into its unique model. While the dimensions of the car varied by inches, there were obvious changes such as roof air vents, window spacing, trolley pole mounts, trucks, door windows, and stoplights. Birney 266 was built in 1921 by McGuire-Cummings, being part of an order of 25 Birneys numbered 250–274. Detroit was reported to have the second-largest fleet of Birneys in North America with 250. (Schramm collection.)

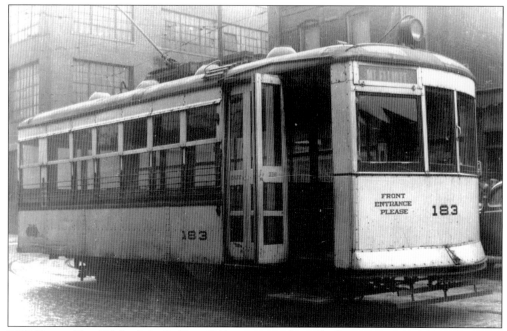

DSR Birney No. 183, built by Brill in 1921, is captured on film by a Detroit rail fan at Atwater and Joseph Campau Streets on the last day of Birneys operating on the Mt. Elliott line. It was one of the Birney cars rebuilt with a double front door entrance for single ended operations. This photograph shows it in need of some maintenance. (Photograph by Elmer Kremkow.)

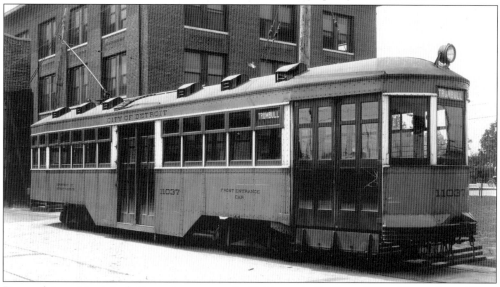

Pictured is a Municipal Operation–era early Kuhlman-built Peter Witt. These Peter Witts were modeled after cars in Buffalo, New York, but the DSR Peter Witts were all four-motored versus Buffalo's two motors. This car is shown alongside of the DSR's administration building at Shoemaker Terminal. Built in 1921, this building served as the main office for the DSR for over 50 years when it closed in December 1972 and operations transferred to a new site in Detroit. The DSR's general manager, the DSR Board of Street Railway Commissioners, and all the major DSR departments were once located in this building. (Schramm collection.)

Three

EARLY DEPARTMENT OF STREET RAILWAYS OPERATIONS
1922–1945

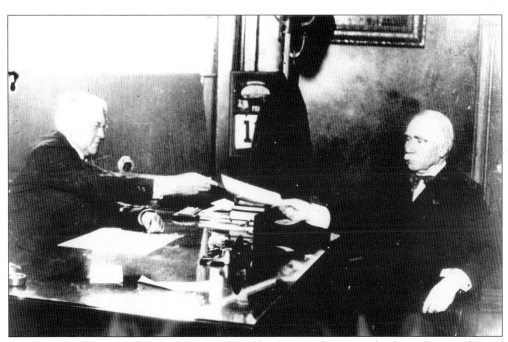

Mayor James Couzens (left) hands over the official City of Detroit check to the president of the Detroit United Railway, Jere Hutchins, for the purchase of the DUR's city operations. This marked the official start for the city's Department of Street Railways (DSR). (Schramm collection.)

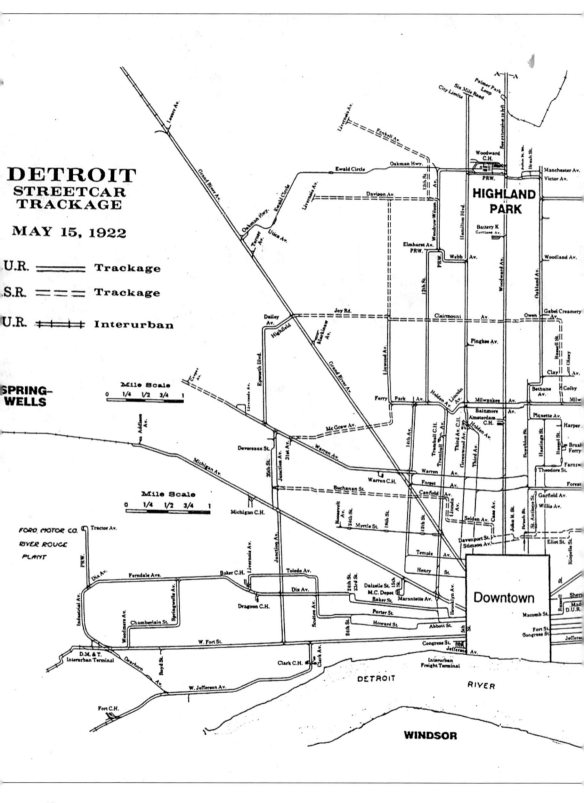

DETROIT
STREETCAR
TRACKAGE

MAY 15, 1922

U.R. ═══ Trackage

S.R. ═ ═ ═ Trackage

U.R. ┼┼┼┼ Interurban

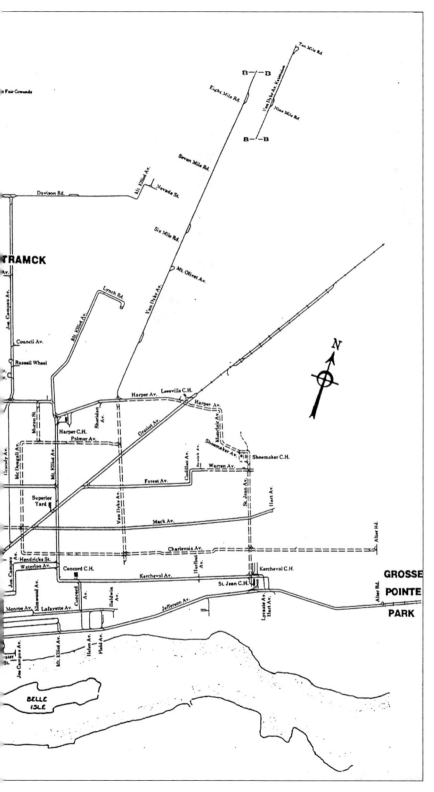

This map shows the streetcar and interurban trackage that existed on the day the City of Detroit, Department of Street Railways officially began operations, May 15, 1922. On that day, the DSR took over from the Detroit United Railway the operations of all streetcar service in the city of Detroit. The DUR continued to operate its interurban cars over DSR tracks within the city, and as well, beyond the city limits. This included service to Port Huron, Flint, Jackson, and Toledo among others.

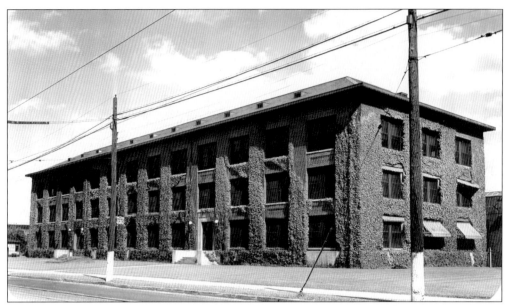

DSR's main administrative office building was located at Shoemaker Terminal on Detroit's east side at Shoemaker and St. Jean Streets. This building was originally built under the city's Municipal Operation in 1921 and officially opened on May 15, 1922. It served as DSR's headquarters until 1972, when new offices at another location replaced these. A state-of-the-art building when it was built, this building never had air-conditioning or computers installed during its 50 years of service to the Department of Street Railways. (Schramm collection.)

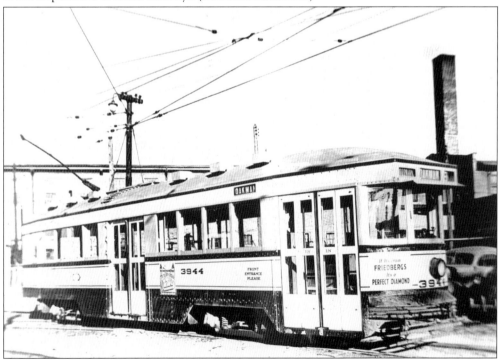

Car 3944, built by the St. Louis Car Company in 1930, seated 52 passengers and is shown here at the Woudward carhouse. It was painted cream with black trim and some striping. (DSR files.)

When the city purchased the single-fare zone of the DUR operation, the town of Leesville (located at Harper and Gratiot Avenues—later absorbed by Detroit) was the city limits. As the city expanded, it obtained control of the DUR right-of-way. There were three sets of track from Eight Mile Road to Gary Terminal near Connors Creek (now in an underground sewer pipe), which was south of Connor Avenue in Detroit, near today's City Airport. The DSR took over the track next to the pavement in this photograph, extended the line to Seven Mile Road on July 5, 1922, and there built a streetcar wye. This was the city limit back then. DSR Peter Witt 3502 is shown at Gratiot and Seven Mile Road in 1925. Note the Detroit United Railway interurban track heading north along Gratiot. At this point in time, the DUR was still providing interurban service north to Mount Clemens and Port Huron. (Tom Dworman collection.)

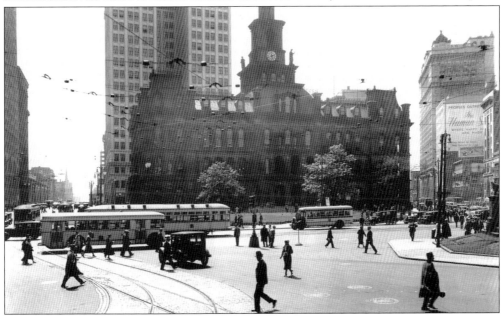

This is Detroit's Campus Martius as seen in this 1930 photograph. One of the first buildings to bite the dust was Detroit's city hall in 1961. Soon this was followed by many more, all in the name of "urban renewal." Presently Campus Martius has returned to its parklike atmosphere with the relocation of new corporate offices and private investment. During the summer months, concerts are offered, while in winter, there is ice skating. (DSR files.)

DSR car 1549, built by Kuhlman in 1911 for the Detroit United Railway, seated 45 passengers. In this view, it is crossing Detroit's "main" street, Woodward Avenue, probably operating on the Baker line. This photograph is dated September 16, 1927. Note the nice selection of some old-time Detroit-built automobiles. (Robert Graham.)

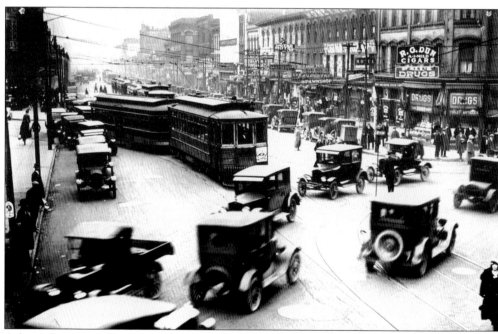

A busy downtown Detroit street is seen loaded with automobile traffic. A DSR 1490 with a trailer is pictured on the Baker line at Michigan and Cass Avenues. (DSR files.)

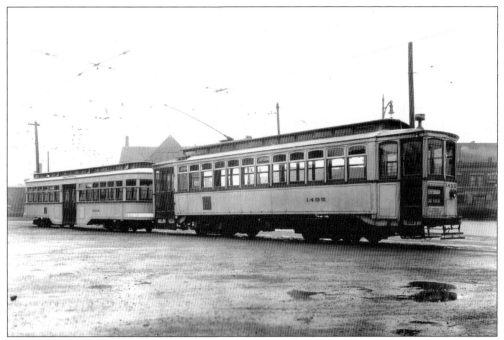

DSR Kuhlman car 1495 and trailer 5014 are both painted in the DSR's third paint scheme, a cream and green body, which was adopted in 1927. The car was built by Kuhlman in 1912 and the trailer also built by Kuhlman in 1915. (DSR files.)

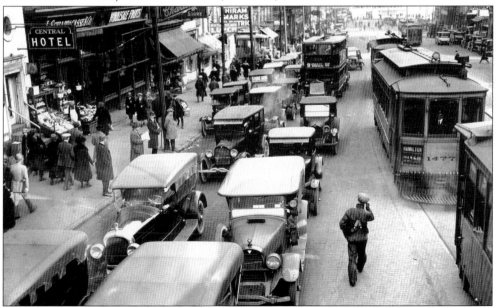

DSR Kuhlman car 1477 is pictured on the Hamilton line with a Detroit Motorbus Company double-decker bus. Also shown are private cars and jitneys with their signs in the windshields advertising destinations and fares. Detroit, during the 1920s, fought to gain control of its city streets and force the independent operating jitneys off them. Finally, in 1928, the city won after a court fight that went to the Michigan Supreme Court. The city felt the jitneys competition was costing the DSR many thousands of dollars in lost fares. (DSR files.)

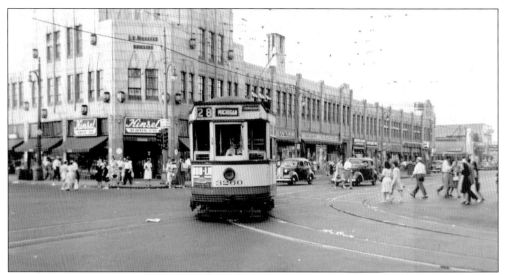

DSR Peter Witt 3260 on the Michigan line is shown here turning onto Schaefer Road in the heart of Dearborn's east-end shopping district around 1946. This line served the Ford Motor Company's Schaefer Loop and also where the double track ended. Beyond Schaefer Road, heading west, the single track of the interurban was used by the DSR after the Detroit United Railway discontinued operating in 1929. The DSR operated over Michigan Avenue to Telegraph Road in Dearborn until February 29, 1932, when the line was cut back to Schaefer due to lack of passengers. The building in the background housed the general offices for the Detroit, Toledo and Ironton Railroad for many years and still stands today. (Photograph by Wilbur Hague.)

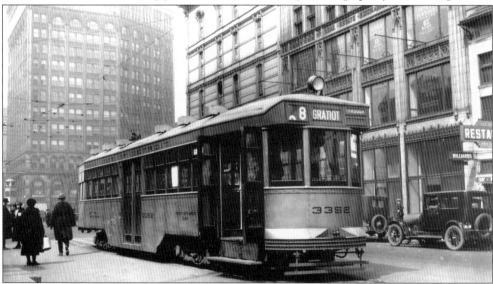

DSR Peter Witt 3352 on the Gratiot car line is shown here loading at Cadillac Square. This car was part of the DSR's second order of Peter Witts built by the St. Louis Car Company in 1922. It is shown here in its original paint scheme with the headlight on the roof. The DSR quickly decided on purchasing these larger Peter Witts and selling the Birneys Detroit mayor James Couzens wanted. Only 56 of the original 200 Birneys offered for sale were in fact purchased by other transit companies, such as Montreal, Cape Breton Tramways, and Union Electric of Indiana. The remainder of these cars were scrapped. (DSR files.)

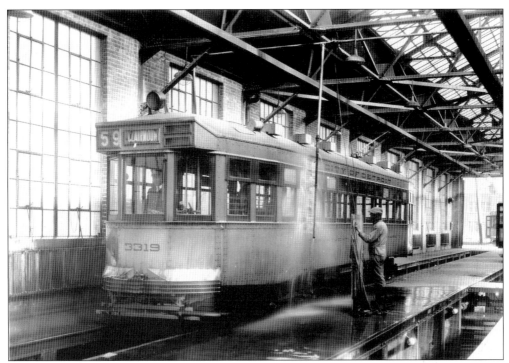

DSR Peter Witt 3319 is getting a wash at Shoemaker car house. The DSR continued to purchase Peter Witts up to 1930, eventually having a fleet of 781. (DSR files.)

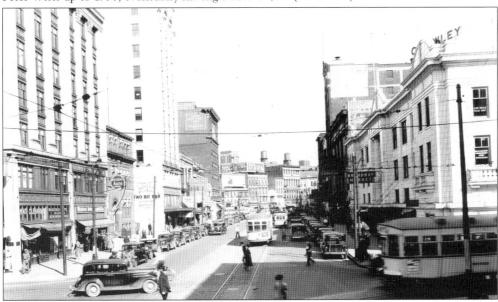

This photograph, taken on May 10, 1935, at Grand River Avenue and Broadway, is looking up Broadway. On the right of the photograph is a famous Detroit landmark, Broadway Market, which was filled with many stalls offering Detroiters the finest of foods. Soon after the streetcar line was discontinued, the market closed and later became a parking lot. On the right side of the photograph today, between Grand River and Gratiot, Detroit's elevated People Mover Rail System operates alongside Broadway. (Ray Ryder collection.)

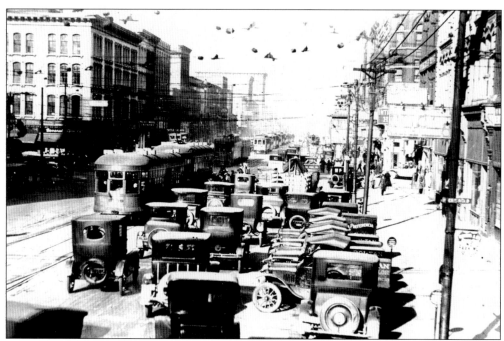

During the 1920s, Detroit began a program to improve the downtown traffic flow. On April 9, 1924, a parking ordinance was passed; perpendicular parking was prohibited as is shown here at Woodward and Jefferson Avenues in downtown Detroit. (Schramm collection.)

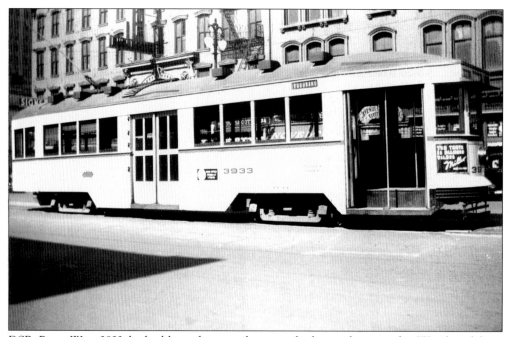

DSR Peter Witt 3933 looks like it has just been washed, traveling on the Woodward line. Purchased in 1930, it was built by the St. Louis Car Company. (Schramm collection.)

A lone DSR Peter Witt travels along Schaefer Highway on the Michigan line in this 1945 photograph of the famous Ford Rotunda located in Dearborn. The rotunda served as an office building when this photograph was taken. Later, beginning in 1953, it would serve as the starting point for the Rouge tours. Special holiday-time displays for the general public were held here for many years. First built for the 1934 Chicago World's Fair, it was later dismantled and moved to Dearborn. It burned to the ground on November 9, 1962. Both the building and the DSR Peter Witt streetcar are now only fond memories. This elevated photograph was taken from Ford's administration building, which served as Ford World Headquarters from 1928 to 1956, by the Michigan Railroad Club's William J. Miller. (Photograph by William J. Miller.)

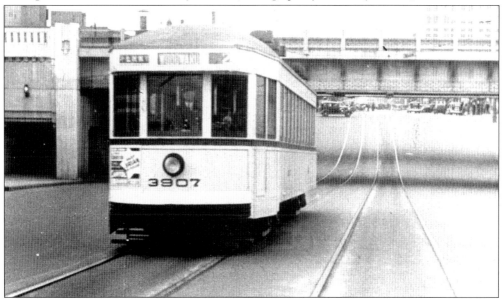

Peter Witt 3907, heading south on Woodward Avenue, has just passed under the Michigan Central and Grand Trunk Railroad tracks. Today the Detroit Amtrak station is located to the left of this picture and serves the Pontiac-Detroit-Chicago Amtrak train corridor. Interestingly certain Amtrak trains now stop at Greenfield Village at an 1856 train station, moved there from Smith's Creek, Michigan, near Port Huron. (DSR files.)

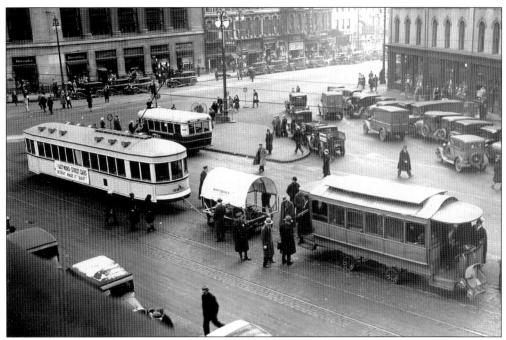

Detroit was hit hard by the Great Depression as auto plants reduced their workforce as car sales fell. On January 8, 1931, crowds estimated at over 100,000 came to downtown Detroit for this parade. Probably the vast majority were unemployed Detroiters hoping this would bring new jobs building Timken trucks for streetcars. The parade included three old-time horsecars and some current DSR streetcars. After the Timken parade, the various pieces of equipment used in the parade were placed on display alongside Detroit's city hall, as shown here, for the public to take a closer look. The display included one of Detroit's original horsecars, No. 73, along with the DSR's latest Peter Witt 3970. The purpose of the parade was to promote the Timken Company's new, quieter trucks being used on the DSR's streetcars. However the Timken trucks were not successful, and eventually had to be replaced with Brill Company streetcar trucks. (DSR files.)

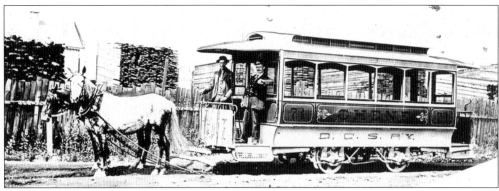

The eight cars in the parade were led by ex-horsecar 73. When the Detroit Citizens Street Railway (DCSRy) converted to all electric streetcars, some horsecars were rebuilt into electrics. Many horsecars were just given away as children's playhouses. Horsecar 73 was found on Helen Avenue in Detroit and used by a shoemaker. A trade was made, giving him a Birney body, and the car retired. This photograph shows horsecar 73 when it was still in service. (DSR files.)

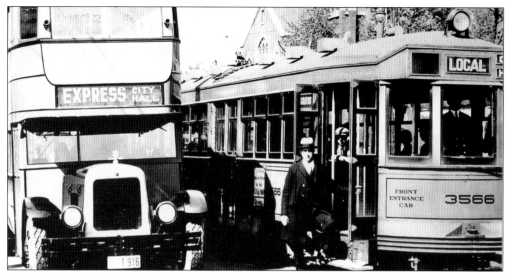

On April 26, 1925, the DSR was studying coordinated rail and coach service. A test was made on Gratiot between downtown and Seven Mile Road, a one-way distance of 7.8 miles. The test vehicles were Peter Witt 3566 and a leased Yellow-manufactured enclosed double-deck coach. On the inbound trip, both vehicles operated as locals. The coach took 47 minutes and 40 seconds for the trip. The streetcar took 10 seconds more. Outbound both vehicles operated as expresses. The coach and car took 28 minutes and seven seconds and 29 minutes, respectively. The DSR concluded that either vehicle could provide the desired faster service if the number of stops were reduced. The test vehicles are posed here prior to the start of the test. (DSR files.)

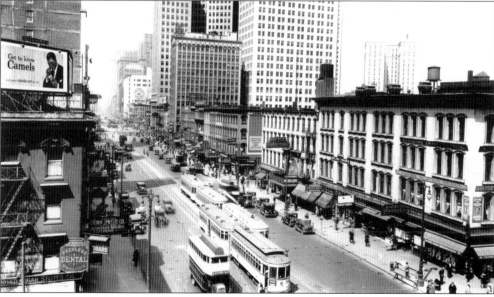

On Woodward Avenue, north of Jefferson Avenue, DSR streetcar 3043 with its trailer is heading south to Jefferson. Alongside is a double-deck motorbus, also heading south. The bus belonged to the Detroit Motorbus Company. It originally came with open top decks, but a way was found to enclose the top for passenger comfort. The canvas top was lowered by the conductor when going under railroad viaducts since Detroit had many very low clearance viaducts. These buses operated as a two-man operation with a driver and a conductor. (DSR files.)

A view of the DSR's Eagle Loop, which received its name when Ford Motor Company began building "Eagle" submarine-chasing boats for the federal government during World War I, is seen here. In 1918, the Detroit United Railway extended the Baker streetcar line and also the Fort Street car line to Eagle Loop. In 1920, Ford started to build its new Rouge plant. Needing more streetcars for storage and to handle shift changes, the Miller Loop was built and opened on June 5, 1927. Employment at the Rouge plant exceeded 100,000 in 1929. Within a year, the Great Depression would reduce the numbers. (Tom Dworman collection.)

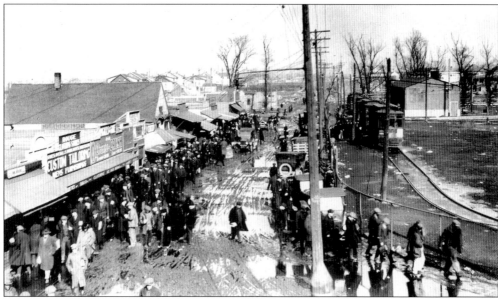

Eagle Loop looks like a shanty town in this image, taken after a few years of operations. The small shed contains vendors selling all kinds of items to the Ford Motor Company employees arriving for work or leaving the plant to go home. Another problem with Eagle Loop was that the employees had to cross the railroad tracks on foot. The building in the center of the loop is a new substation to boost line voltage for the concentration of cars. Soon all this would change with the construction of the DSR's new Miller Road Loop. (Tom Dworman collection.)

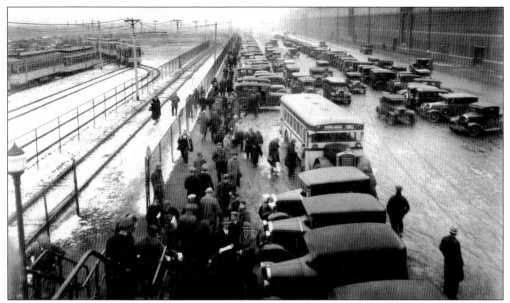

The Ford Motor Company's Miller Loop is to the left of the photograph, showing the lineup of DSR streetcars ready to go into service. The heavy concentration of streetcars required at shift changes required the use of catenary overhead. A second adjacent yard is not shown in the photograph. To the right is Miller Road, loaded with jitneys and a DSR cut-down double-deck bus in the 500 series. These jitneys, for a fee, offered competing service to the DSR, taking Ford workers home. The jitneys were finally banished in 1928. (DSR files.)

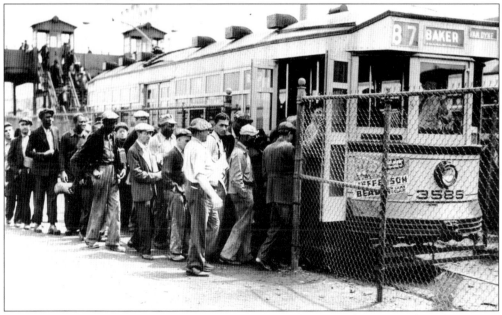

At the DSR's Ford Motor Company Miller Loop in Dearborn, employees at a shift change load a Peter Witt streetcar to head home for the day. The capacity of the Miller Loop was to be able to load or unload 20 streetcars simultaneously and store 32 streetcars. Notice the nearby Miller Road overpass, which crossed over Miller Road to allow employees to remain away from the streetcar tracks and bus and car traffic. (DSR files.)

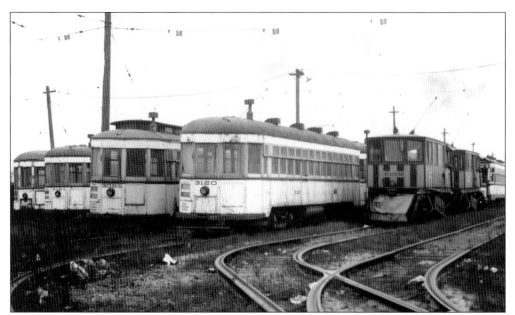

Seen here is a lineup of various DSR passenger and work-cars at the Baker car house, including the DSR's sweeper X-109, one of 14 units built by McGuire Cummins in 1924. The Baker car house was located on Detroit's lower west side at Livernois Avenue and Vernor Highway. The DSR had a large storage yard where many retired passenger and work cars ended up, including the "Blue Streak 401" and the three-car articulated train. (Howard Ziegel collection.)

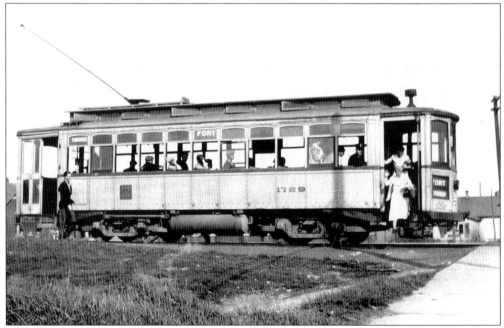

DSR 1729, assigned to the Fort Street line, operates over the former Detroit, Monroe and Toledo Short Line Railway on its way to the DSR's Gleason Wye, shown here at Pleasant Avenue. Many of the street crossings along this stretch of track had railroad crossing signs. (Photograph by Elmer Kremkow.)

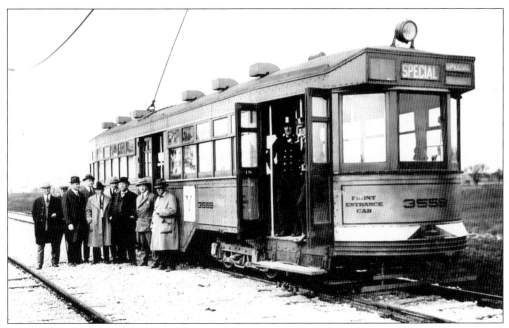

On the Northwest Belt line are Charles Oakman and other city officials on an inspection tour of the new line prior to the start of regular streetcar service on June 13, 1925, from Grand River Avenue to Michigan Avenue. The backward trolley pole indicates that only a single track had been completed. (Ray Ryder collection.)

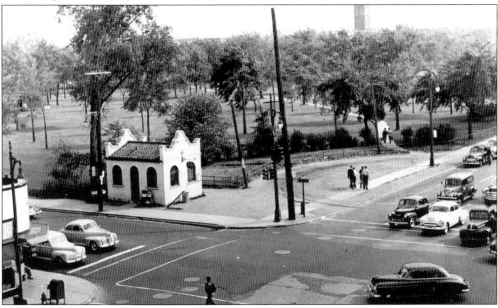

This Spanish-style waiting room was located on the campus of the University of Detroit at McNichols Road and Livernois Avenue, and was called University Station. It served the passengers of the Fourteenth streetcar line as well as the passengers from the DSR's Livernois Avenue and Six Mile Road coach lines. Streetcar service ended at this corner when the Fourteenth line stopped running on July 18, 1948, being replaced by the Linwood bus line. (Schramm collection.)

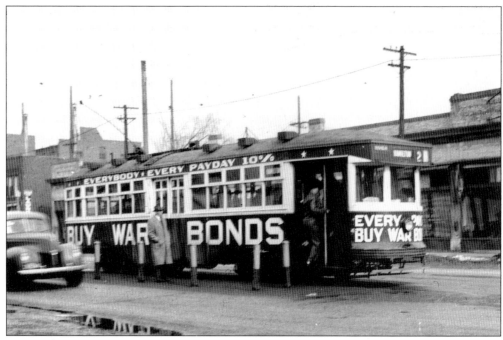

One of the DSR's Peter Witts is painted up to promote the purchase of war bonds. (Howard Ziegel collection.)

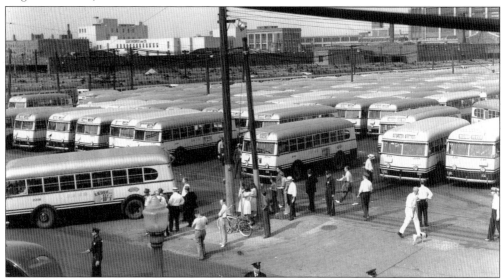

The DSR continued to have many union problems throughout the 1930s resulting from establishing the automotive division of the DSR in 1925. Employees who wanted to transfer from the rail division to the bus division had to resign first, losing their seniority. Now, as rail lines were being replaced by buses, the rail men wanted to retain their seniority on the board. The bus operators formed a union named the Motor Coach Operators Association. After many strikes, citizen votes, and court hearings, it was finally settled in favor of Division 26 of the Amalgamated Association of Street, Electric Railway and Motor Coach Employees of America. This photograph shows the Highland Park yard full of buses. This strike lasted from August 20 to 24, 1941, and was about sole bargaining rights for the union. (Schramm collection.)

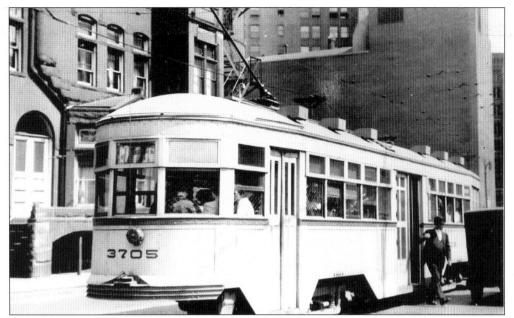

During the Depression in 1933–1934, the federal government provided grants to create jobs. The DSR received funds to install rear doors on its Peter Witts in an attempt to speed up unloading. The rear door was controlled by an extra lever on the conductor's left. If someone got caught in the door, a bell rang. The DSR planned to convert all 781 Peter Witts, but only 38 were ever completed. The first cars completed, 3504 and 3548, went into service on Jefferson Avenue on January 23, 1934. (DSR files.)

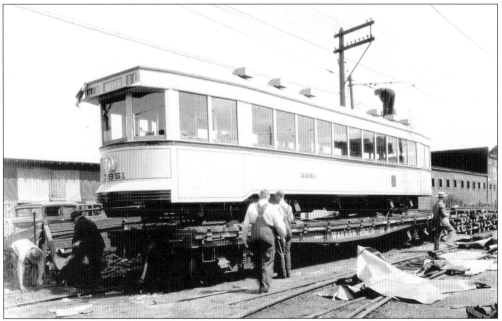

DSR Peter Witt 3851 arrives on a railroad flatcar from the St. Louis Car Company in 1930. The car contained many features built into Peter Witt No. 3850, built by the DSR in its own shops years earlier. (DSR files.)

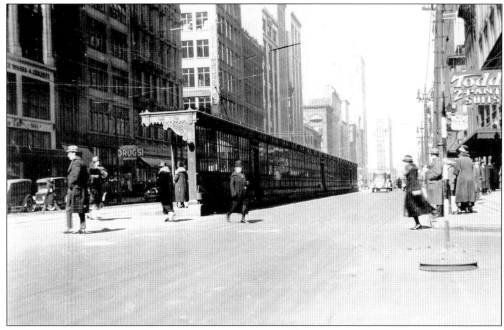

This large DSR shelter was one a kind. Built in 1925 for $12,000, its roof and sides were removed in 1928. After having wanted it built, the downtown store owners soon wanted it removed, complaining that streetcar riders could not see the stores' window displays. This shelter was located at Woodward and Gratiot Avenues. (Ken Homburg collection.)

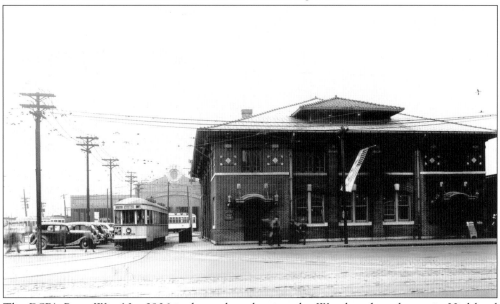

The DSR's Peter Witt No. 3906 is shown here leaving the Woodward car house in Highland Park, heading for a day's run on the Woodward car line. The Woodward Terminal dates back to the Detroit United Railway. Built about 1915, it was located directly across the street from the Ford Motor Company's Highland Park plant. The terminal office building included lockers and showers on the second floor, while on the ground floor there were lounging, cashier service for change and transfers, and terminal office facilities. (Schramm collection.)

DSR Peter Witt 3248 is pictured here in 1940 at the Highland Park shops awaiting a complete rebuilding. It looks like it requires a lot of restoration; probably why it was picked. This was one of the Municipal Operation cars purchased in 1921 for joint service with the Detroit United Railway. (DSR files.)

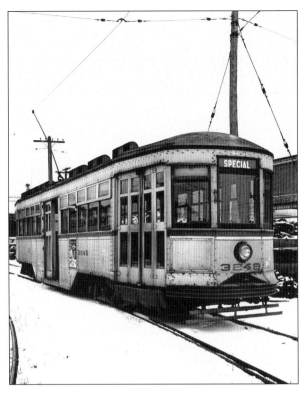

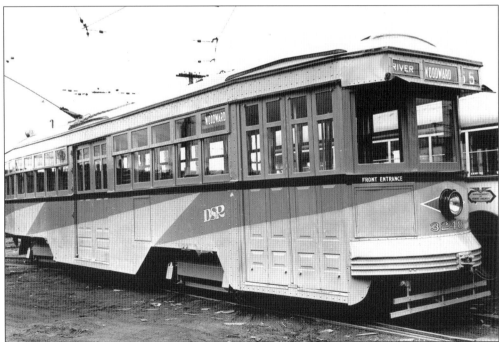

Peter Witt 3248 was one of the original Peter Witts purchased in 1921. It is shown here after being rebuilt in the DSR shops, now wearing a special DSR paint scheme. This car was considered by motorman to be the fastest DSR car and was nicknamed "Hot Rod." (DSR files.)

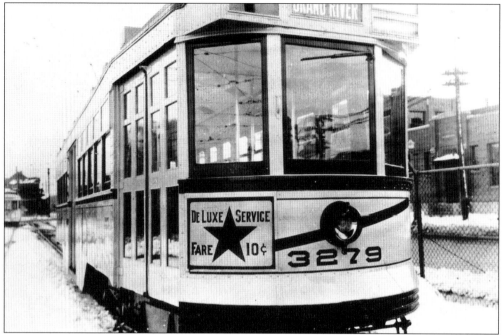

Seen here is the DSR Peter Witt 3279. This was a special Deluxe Peter Witt that the DSR experimented with on several lines including Grand River. It charged a premium fare of 10¢ to ride this car. It was no faster than the regular car on the line; however, it did provide a guaranteed seat. It went into service on Grand River on November 25, 1932. Patronage was low because few riders, during the Great Depression, could afford the extra 4¢ charged. (Richard Andrews collection.)

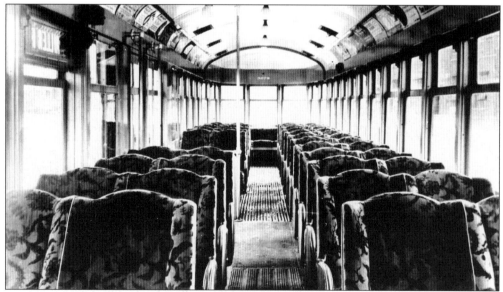

DSR Peter Witt 3279 was a Deluxe streetcar that the DSR operated. This photograph shows the special seats that were installed. This was a one-man car operation. After operating on Grand River until May 3, 1933, it was transferred to the Woodward line where it operated until June 1, 1933, when the special Deluxe service itself ended. (Richard Andrews collection.)

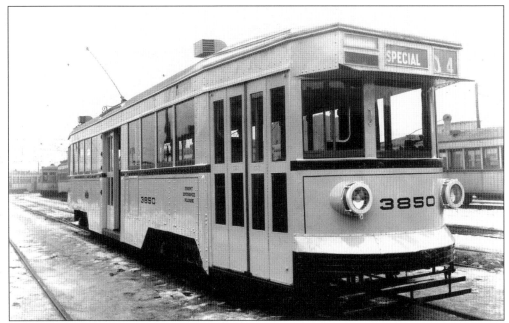

DSR Peter Witt 3850 is pictured in the yard. On July 22, 1928, the DSR Commission approved $15,000 to construct 3850 as an experimental Peter Witt. Among the changes were the addition of twin headlights, Timken-52 trucks, and four 50-horsepower motors, as well as large single-pane windows with steel frames. Many of these features were later ordered in the last Peter Witts, numbered 3851–3980. On July 17, 1929, Peter Witt 3850 was ready for service and placed on the Trumbull line. Later it was in the Deluxe streetcar service along with Peter Witt 3279 on the Grand River and Woodward lines. In the late 1940s, after an accident, it was rebuilt with a single headlight and renumbered 3968. (DSR files.)

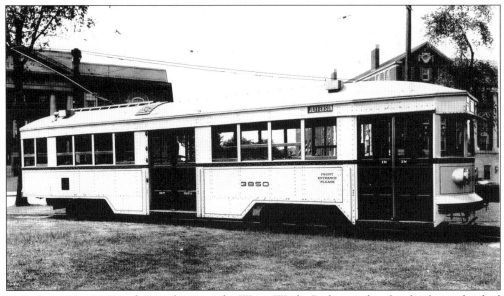

DSR Peter Witt 3850 is shown above on the Water Works Park spur shortly after being finished in its original paint scheme. (DSR files.)

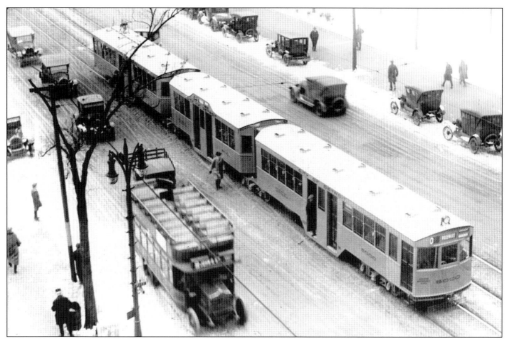

The DSR three-car train 5000 is in service on Woodward Avenue. Note the Detroit Motorbus Company double-decker bus alongside. On Wednesday, February 20, 1924, the first three-car articulated train built in the United States arrived in Detroit following a two-day, 260-mile rail trip under its own power from Cincinnati. It arrived at the Fort Street west city limits at 7:30 p.m., where Woodward Avenue crews took charge and operated it from the Woodmere wye on Fort Street to the Woodward car house. On Thursday, February 21, 1924, the train was put into operation on the Woodward line, making two scheduled morning trips and one evening trip. On the latter, from downtown to the Michigan State Fairgrounds, it carried 500 passengers during the trip. (DSR files.)

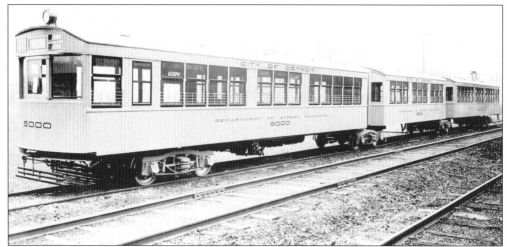

DSR's three-car train No. 5000 is pictured as received from the Cincinnati Car Company. Only the front and rear trucks were powered on this train. The rear trucks carried very little weight, resulting in very slippery acceleration. The train's four motors were 60 horsepower in contrast to the 35 horsepower motors used on the DSR's Peter Witts. (Richard Andrews collection.)

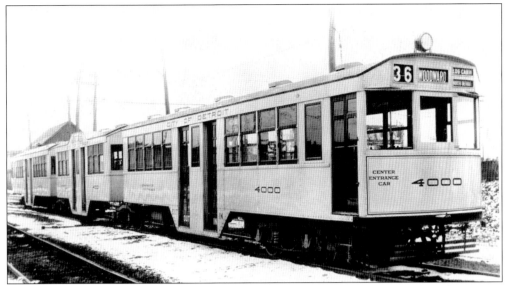

DSR's three-car train is shown in the yard, renumbered with its second series of numbers: 4000, 4001, and 4002. Having large numbers of passengers, the DSR attempted to solve the problem with this three-car train. Ordered from the Cincinnati Car Company, it came to Detroit under its own power and was put into service on the Woodward line on February 21, 1924. The DSR had planned to purchase 10 of these three-car units, called the "articulated train." It proved to be unsatisfactory due to it being underpowered for the passenger load it was designed to carry. Only two of the four trucks were powered, resulting in slow acceleration. It was later used on the Baker line, a heavy passenger load streetcar line carrying workers to the Ford Rouge complex. (DSR files.)

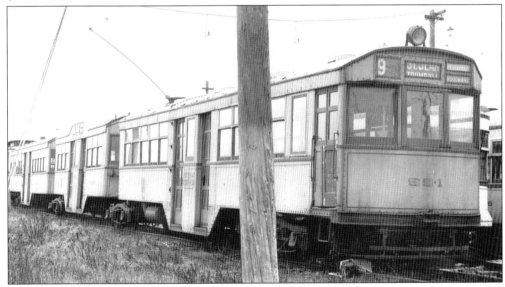

DSR's three-car train is shown here in the yard, renumbered for the third time to 99 1–3. Notice that the trolley pole has been moved to the front car from the rear car of the train. The DSR was never able to obtain the planned use of this type of train, and the original plan to purchase 10 such trains was dropped. The train was used on Woodward Avenue and the Baker lines; however, it spent most of its time in the yard and not in service. (DSR files.)

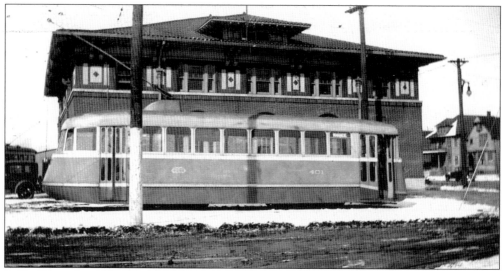

DSR 401, nicknamed the "Blue Streak" to reflect its basic colors of silver and blue, is shown alongside the Baker car house. Built in 1934, this was the third and last passenger streetcar built by the DSR. The DSR had originally planned to build 35 from parts salvaged from scrapped Birneys. It was equipped with four 25 horsepower motors from scrapped Birneys. They were field-tapped for better performance and were mounted on standard PL-35 trucks which generated less track clatter than other trucks. This car also featured many advanced features for its time, including welded car sides, safety glass, no roof ventilators, indirect passenger lighting, and a streamlined body; it seated 39 passengers. However, due to its low ceiling for tall passengers, the DSR used 401 only on the Woodmere line, which had low ridership, and then only at night. It started service on the Woodmere line on October 31, 1934, and was retired from service in 1948. (Richard Andrews collection.)

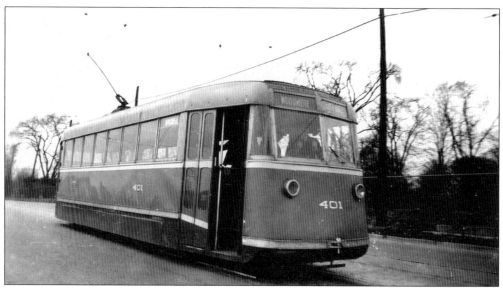

DSR 401, the "Blue Streak," is shown in service on the west end of the Woodmere line at Dearborn and Fort Streets. (DSR files.)

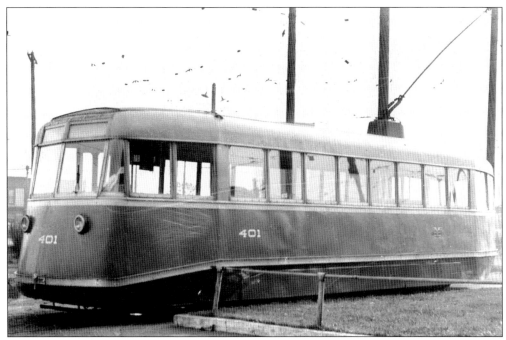

"Blue Streak" 401 is pictured at the Baker car house. (Photograph by George Kuschel.)

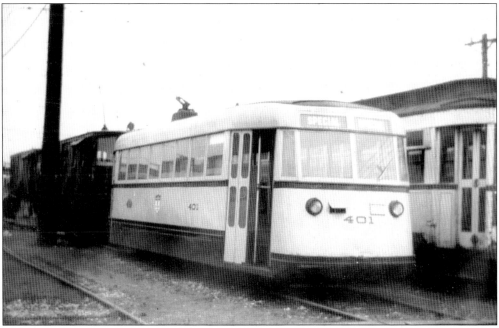

DSR 401 is shown in its final paint scheme at the Baker car house. This car was originally nicknamed the "Blue Streak" to reflect its silver and blue paint finish. During World War II, this car was brought out of storage, repainted in the DSR's fleet colors of cream and dark trim, and placed on the Woodmere line, along with the one-man operated Peter Witts. (Richard Andrews collection.)

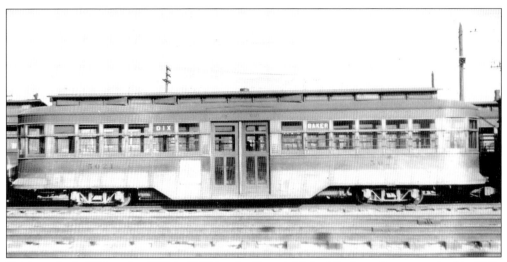

Kuhlman built DSR trailer 5021 in 1915 for the Detroit United Railway. It was received in 1921, when the city took over day-to-day operation, track, and rolling stock from the DUR. (Richard Andrews collection.)

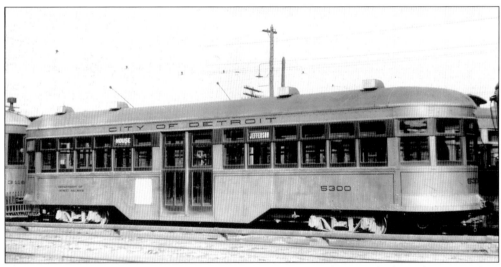

DSR trailer 5300, in the yard, was built by the DSR in 1922. The DSR built trailers 5300–5324 in 1922 and 5325–5349 in 1923. This was the first of the 50 trailers built by the DSR in 1922. (Richard Andrews collection.)

Four

LATER DEPARTMENT OF STREET RAILWAYS OPERATIONS

1946–1956

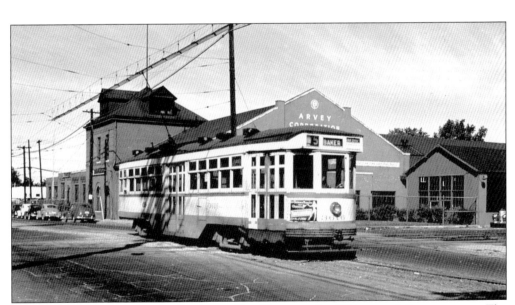

Peter Witt 3616, built by the St. Louis Car Company in 1924, seated 52 passengers. The photograph shows it crossing Michigan Central Railroad's Bay City subdivision. Among the DSR's few private right-of-ways, this eastbound car is running over an open section in the center of Nevada Avenue, east of Filer Street at the Michigan Central Railroad Bay City Division tracks, near the end of the Baker line. This was the DSR's only two-direction single-track operation and was protected by block signals. Signals were used at the end of each block. This unique operation was a result of the abandonment of the East Lafayette streetcar line in 1939. This also was the only location on the DSR that used Trolleyguard—the patented mesh that prevented "dewirements" at railroad crossings. (Photograph by Tom VanDegrift.)

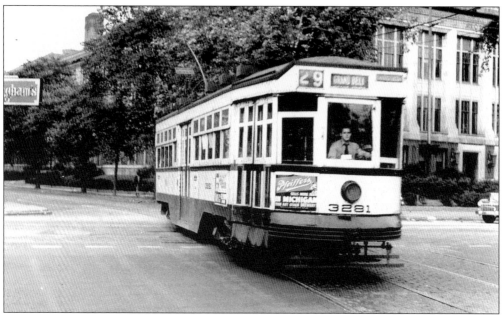

DSR Peter Witt 3281, built by Kuhlman in 1922, is seen here at Owen and Woodward Avenues in 1948. This is a Grand Belt line car operating on a temporary detour over the regular Clairmount line, shown here traveling westbound passing Detroit's Northern High School. The detour over this track was due to the construction of street overpasses being built over one of Detroit's newest freeways, the John C. Lodge. (Photograph by Wilbur Hague.)

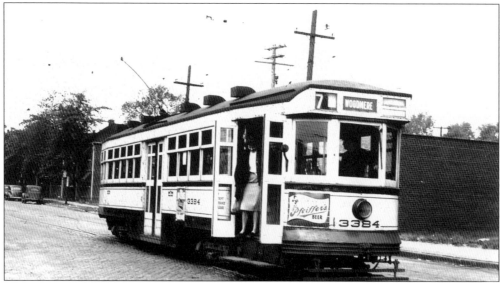

DSR Peter Witt 3384, built by the St. Louis Car Company in 1922, is shown here on the Woodmere line at Woodmere Avenue and Fort Street in 1947. When the Birneys were replaced on the Woodmere line in 1935, it became the first line to be permanently assigned one-man operated Peter Witts. The performance of these cars was derated with replacement of the 35 horsepower motors with 25 horsepower motors salvaged from scrapped DSR Birneys. Post-war conversions of the Peter Witts to one-man operated cars retained the 35 horsepower motors. (Photograph by Wilbur Hague.)

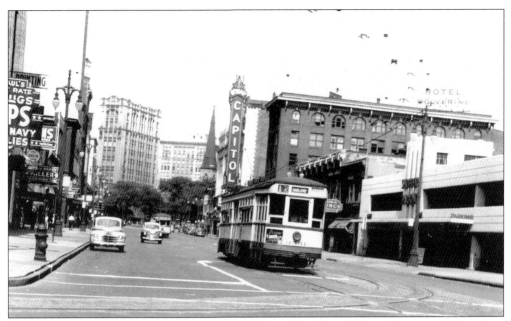

DSR Peter Witt 3531 appears on the Oakland line at East Grand River Avenue and Broadway in downtown Detroit in 1947. This car was built by Osgood-Bradley in 1923. The car is heading toward Gratiot Avenue and Library Street. On the left is Broadway Market, and just up the street is the Capitol Theatre. This theater has been rebuilt and is today the Detroit Opera House. (Photograph by Wilbur Hague.)

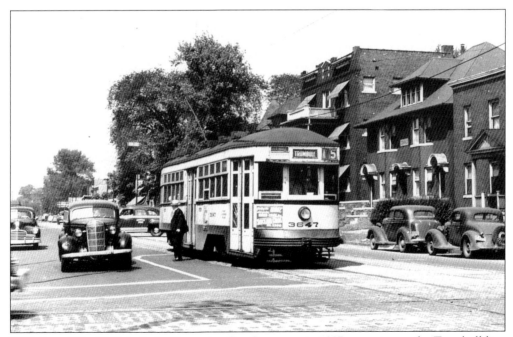

DSR Peter Witt 3647, built by Cummins Car Company in 1927, operates on the Trumbull line on September 6, 1947. This car is inbound on Trumbull at Canfield Avenues. (Photograph by Wilbur Hague.)

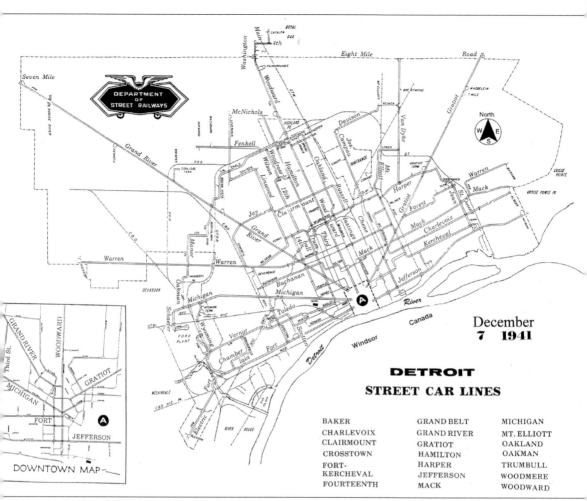

DEPARTMENT OF STREET RAILWAYS

December 7 1941

DETROIT
STREET CAR LINES

BAKER	GRAND BELT	MICHIGAN
CHARLEVOIX	GRAND RIVER	MT. ELLIOTT
CLAIRMOUNT	GRATIOT	OAKLAND
CROSSTOWN	HAMILTON	OAKMAN
FORT-	HARPER	TRUMBULL
KERCHEVAL	JEFFERSON	WOODMERE
FOURTEENTH	MACK	WOODWARD

DOWNTOWN MAP

These two DSR maps, from 1941 and 1951, which show the DSR's streetcar lines in operation, highlight the dramatic streetcar abandonments that occurred during this short 10 year period. Going into World War II, the DSR had 20 streetcar lines operating across all areas of the city. By 1951, this had been reduced to just five operating lines covering the major arteries of the city. It is

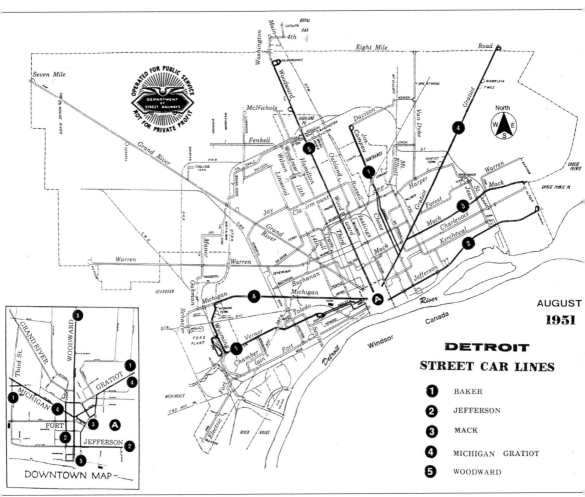

DETROIT

STREET CAR LINES

August 1951

1	BAKER
2	JEFFERSON
3	MACK
4	MICHIGAN GRATIOT
5	WOODWARD

interesting to note that these last five lines included four of the earliest streetcar lines that were built in Detroit in 1863. The second oldest line operating, Woodward, would in just a few short years, be Detroit's last streetcar line, when it too was abandoned on April 8, 1956.

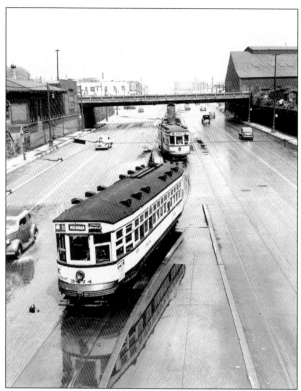

DSR Peter Witt 3474, built by McGuire-Cummings Car Company in 1923, was photographed on Michigan Avenue near the Cadillac automobile plant at Clark Street. Note the unusual offset loading platform used by the DSR streetcars here. Passengers boarded the streetcars from a mid-street safety zone. (Photograph by Wilbur Hague.)

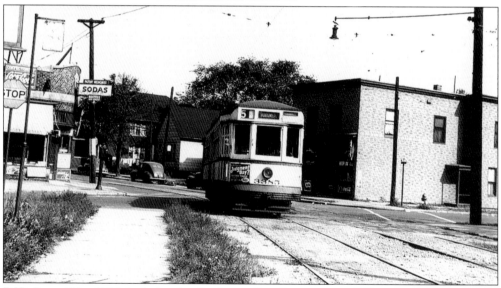

DSR Peter Witt 3385, built by the St. Louis Car Company in 1922, operates here on the Woodmere line on Detroit's west side at Toledo and Clark Streets in 1947. The Woodmere line had one of the DSR's few private right-of-ways, required here to avoid an "S" curve in the street. The DSR also had private right-of-ways on its Baker, Fort-Kercheval, Grand River, Gratiot, Hamilton, Mack, Michigan, Oakman, Trumbul, and Woodward lines. This streetcar line was replaced on July 18, 1948, by the DSR's Toledo, Springwells, and West Jefferson coach lines. (Photograph by Wilbur Hague.)

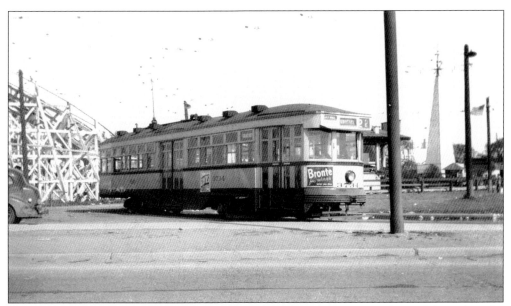

Car 3734, built by the St. Louis Car Company, seated 52 passengers and was delivered to the DSR in 1927. Captured in this May 1946 photograph, it is shown at Eastwood Park in East Detroit (now called Eastpointe). This amusement park was located on the edge of Detroit at Gratiot and Eight Mile Road. It was a large amusement park with plenty of rides for kids and adults. The car is leaving the Eastwood Loop at the end of the Gratiot car line and heading south back to downtown Detroit. (M. D. McCarter.)

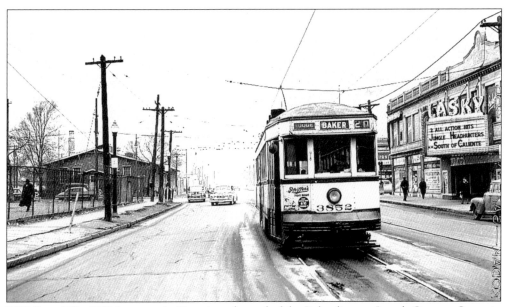

DSR Peter Witt 3852 lays over in Detroit at the end of the Baker line on Joseph Campau Street in front of one of Hamtramck's leading retailers and local legends, Lasky Furniture. No. 3852 was built by the St. Louis Car Company in 1930 and, in 1947, was rebuilt by the DSR for one-man operation. It was one of the last 12 Peter Witts to be retired by the DSR. (Photograph by B. Henning.)

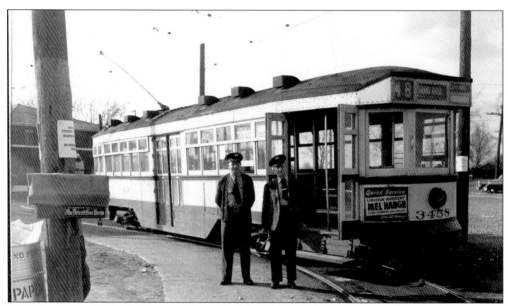

DSR Peter Witt 3458 is laid over at the end of the Grand River streetcar line at Seven Mile Road and Grand River Avenue, shown here with the car's conductor and motorman in DSR's loop adjacent to the Michigan State Police Post in Detroit. This was the last day of streetcars on the Grand River line, May 3, 1947. Gasoline-powered coaches would replace the streetcars the next day. They themselves would be replaced when on September 5, 1951, St. Louis Car Company trolley coaches would take over the Grand River line and remain in operation until November 16, 1962. (Richard Andrews collection.)

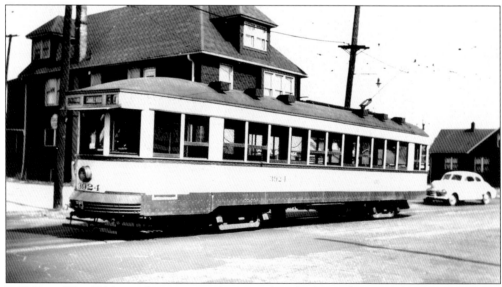

DSR Peter Witt 3924 is at the turnaround wye on the Charlevoix line in this 1949 photograph. Charlevoix had been one of the first streetcar lines built by the city's Municipal Operations in the 1920s. The Charlevoix car line was replaced by the Vernor coach line on July 17, 1949. (Photograph by Wilbur Hague.)

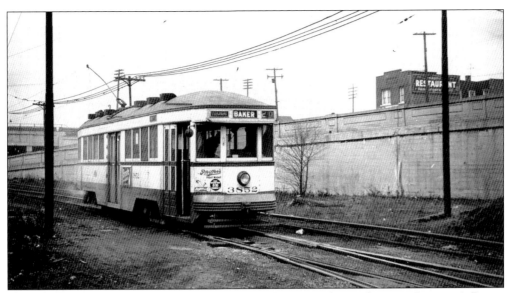

DSR Peter Witt 3852 has just left the Miller Road Loop at the Ford Motor Company's Rouge plant. Eagle Pass is where the Fort and Baker cars from the south joined the cars coming from Michigan Avenue to the north. All cars passed under the Pere Marquette Railway en route to the Miller Road Loop. Shown here is a Baker line car outbound from the Ford plant on its way to downtown Detroit. Built in 1930 by the St. Louis Car Company and later converted to one-man operation in 1947, it was one of the last of the DSR's Peter Witts to be retired from service. (Photograph by Wilbur Hague.)

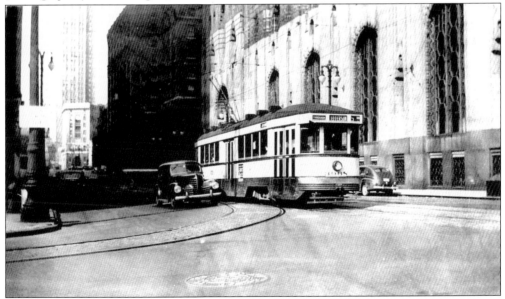

DSR Peter Witt 3968, on Griswold Street in downtown Detroit, is about to turn onto Jefferson Avenue for the trip to the Wayburn Loop at the Detroit–Grosse Pointe city limits. This car was built by the St. Louis Car Company in 1930 and was part of the last order of Peter Witts ordered by the DSR, numbered 3851–3980. These particular cars were rated to operate eight miles per hour faster than the earlier St Louis–built Peter Witts purchased by the DSR. The building on the right is the Union Guardian Building. (Photograph by Wilbur Hague.)

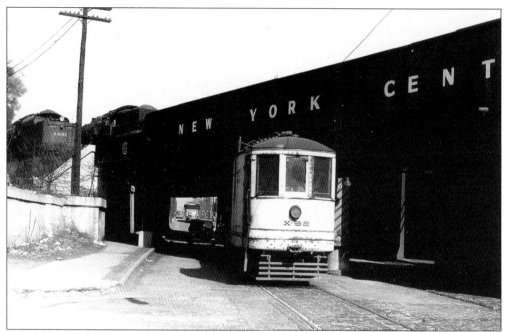

The DSR's work car X-92 is shown carrying supplies. This photograph was taken on the Grand Belt line at Milwaukee Avenue and Hastings Street in 1948. This work car came from the Detroit United Railway and was rebuilt by the DSR. It was retired in 1951. (Photograph by Wilbur Hague.)

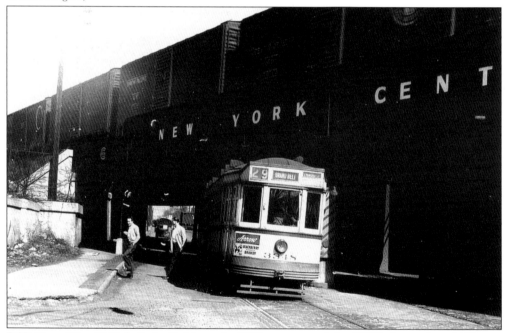

DSR Peter Witt 3348, built by Kuhlman in 1922, was part of the DSR's first order of 100 cars purchased, numbered 3250 through 3349. Here 3348 is photographed on the Grand Belt line passing under the New York Central Railroad's viaduct on Milwaukee Avenue at Hastings Street in 1948. (Photograph by Wilbur Hague.)

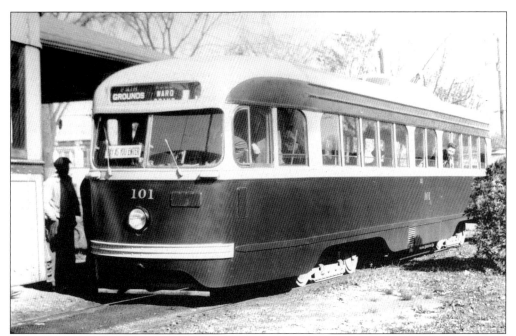

PCC 101 is pictured at the Fairgrounds Loop, still in its original Pittsburgh Railway colors. This is one of two air-electric PCC demonstrators that the DSR purchased in August 1945. Both of these cars (100–101) had been intended for delivery to Pittsburgh before being diverted from the St. Louis Car Company assembly line. The standard gauge trucks, required to convert this PCC from the wider Pittsburgh Railways gauge, came from an order originally intended for Washington, D.C. (Howard Ziegel collection.)

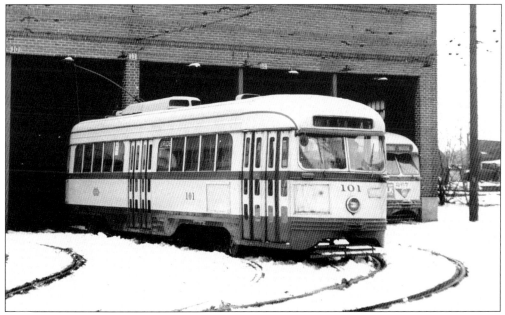

DSR's Presidents Conference Committee (PCC) car 101 is at the Highland Park car house. This car was originally a Pittsburgh Railways car that was diverted to the DSR for their use and repainted in DSR colors, delivered in October 1945. (Ray Radway.)

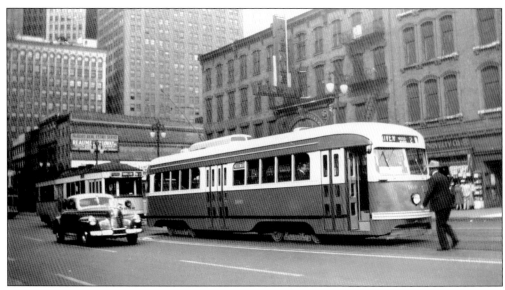

PCC 100 appears in service on the Woodward line in downtown Detroit. This car was purchased by the DSR in August 1945 from the St. Louis Car Company and delivered in October 1945. This was one of two air-electric demonstrators originally destined for Pittsburgh Railways diverted for use by the DSR to test out the PCC over its lines. This car would eventually be renumbered 141 and repainted into the DSR's traditional cream and red color scheme. On one occasion, this car ventured out of Detroit on a Michigan Railroad Club charter over the DSR's Woodward line extension to Royal Oak, Michigan, shortly after being delivered to the DSR. This is the only known time that a DSR PCC ever operated over the Royal Oak line. (Schramm collection.)

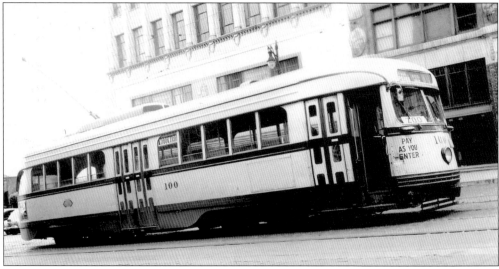

This rare photograph of DSR PCC 100, still carrying the original Pittsburgh Railways number, but repainted in the DSR's paint scheme, is seen operating on the Woodward line, passing one of downtown Detroit's landmarks, Vernors Ginger Ale. This PCC would later be renumbered 141. The renumbering was to group the DSR's PCC fleet between the Westinghouse and General Electric supplied motors and controllers. Please note the lack of standee windows in both this and the DSR's PCC 101. (Richard Andrews collection.)

Looking north on Woodward Avenue in Highland Park, the building in the foreground is Ford Motor Company's famed Highland Park plant, where, in 1910, Henry Ford began building the Model T automobile after moving there from his Detroit Piquette plant. The building with the five chimneys was the power plant, torn down in 1956. Part of this Ford plant remains today, used primarily for storage. Here DSR PCC No. 120, built by the St. Louis Car Company in 1947, heads south to downtown Detroit. (Photograph by Tom Dworman.)

DSR PCC 268 heads south on Woodward Avenue, having just left the Michigan State Fairgrounds. This two-mile open-track section existed from McNichols Road to the fairgrounds, located just south of Eight Mile Road, after the DSR tracks to Royal Oak were abandoned in 1947. Car 268 was part of the last order of PCCs for the DSR, 181 to 286, built by the St. Louis Car Company in 1949. Woodward was the second streetcar line built in Detroit in 1863 and soon it was the last one to operate on April 8, 1956. PCC 268, after 25 years of service in Mexico City, was returned back to the Detroit area in the early 1980s. This car may be seen today, painted in DSR colors, where it is currently being restored by the Michigan Transit Museum at Selfridge Air National Guard Base near Mount Clemens. (Photograph by Tom Dworman.)

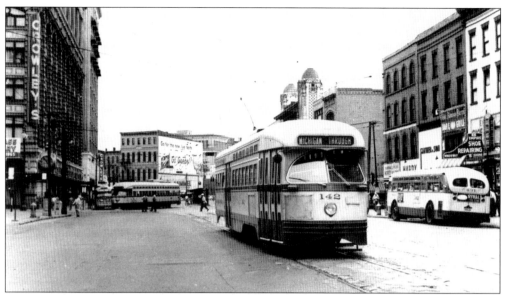

DSR PCC 142 is pictured on Monroe Street, east of Woodward Avenue, having just passed one of Detroit's major department stores, Crowley Milner and Company, just left of the picture. The PCC was operating on the combined Gratiot-Michigan line. In the distance, a Jefferson line PCC is shown turning onto Farmer Street after traveling from the Gratiot car house for rush hour service on Jefferson Avenue. The Jefferson car house had already been closed at the time of this photograph. (DSR files.)

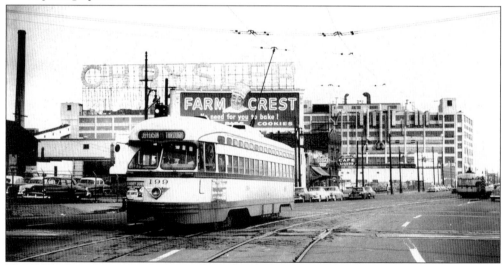

The DSR's President's Conference Committee (PCC) streamliner streetcar 199, built in 1949 by the St. Louis Car Company, shown here on Jefferson Avenue passing the Chrysler Jefferson Avenue assembly plant at the Detroit Terminal Railways crossing. PCC 199 was part of the last PCC order placed with St. Louis Car. The delivery of these cars (181–286) permitted full-time streamliner service on the Michigan, Gratiot, and Jefferson lines in addition to Woodward. It is noteworthy that an interchange between the DSR and the Detroit Terminal Railroad at this location was active for delivery of freight cars (chlorine tank cars, filtration gravel, and coal car shipments, mostly at night) to the city's Waterworks Park facility along Jefferson Avenue until 1942. (Photograph by Tom Dworman.)

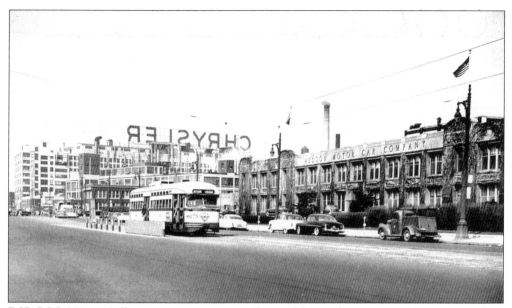

DSR PCC 202, on Jefferson Avenue, passes in front of the Hudson Motor Car Company plant on Detroit's east side at the northeast corner of Connor and Jefferson Avenues. Shown in the picture on display in front of the Hudson plant is a Hudson Jet, an early compact car that, unfortunately, sold poorly in 1952. The Hudson and Chrysler plants pictured here are now gone. (Photograph by Tom Dworman.)

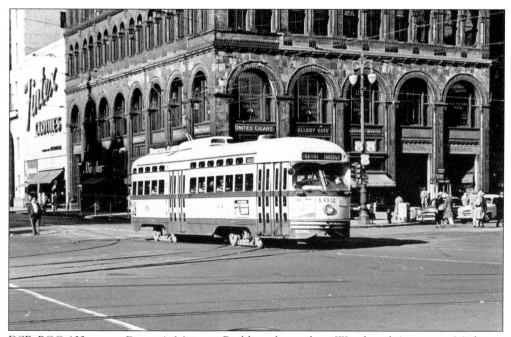

DSR PCC 102 passes Detroit's Majestic Building, located on Woodward Avenue at Michigan Avenue in downtown Detroit. This 1947 St. Louis Car Company–built PCC is operating eastbound on the Gratiot line. (Ray Radway.)

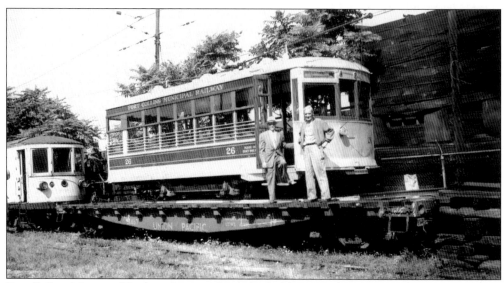

Fort Collins Municipal Railway Birney 26 is unloaded from a railroad car at the DSR's Highland Park shops in August 1953. It started service in Cheyenne, Wyoming, and ended service in Fort Collins, Colorado. The National Railway Historical Society's Midwest Chapter arranged to send the car by train to the DSR's Highland Park shops. It participated in the 90th Anniversary Parade of Streetcars in Detroit on August 16, 1953. After the parade was held, the Birney went on permanent display in the Henry Ford Museum at Greenfield Village in Dearborn, Michigan. (Schramm collection.)

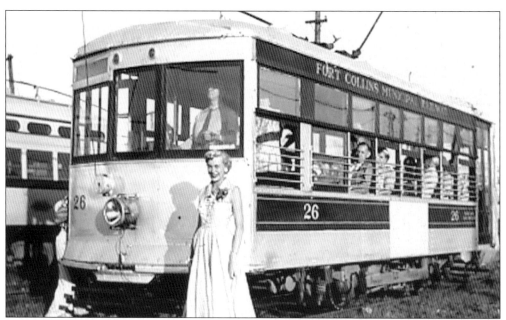

Fort Collins Municipal Railway Birney 26 is shown here with a very attractive Miss DSR for August 1953 at the DSR's Wyoming car house. This was a fan trip arranged by the Michigan Railroad Club on August 16, 1953, to celebrate 90 years of streetcar service in Detroit. Unfortunately streetcar service did not make the 100-year mark in Detroit, as all streetcar service ended on April 8, 1956, less than three years after this picture was taken. (Richard Andrews collection.)

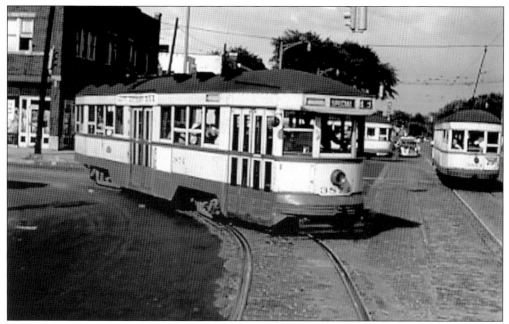

A Michigan Railroad Club charter is pictured on Jefferson Avenue at the Wayburn Loop. Peter Witt 3874 is shown passing car 3863 on August 16, 1953. Please note the brick paved street that still shows, in 1953, the in-bound tracks from the Detroit United Railway, an operation that had been abandoned 30 years earlier. (Richard Andrews collection.)

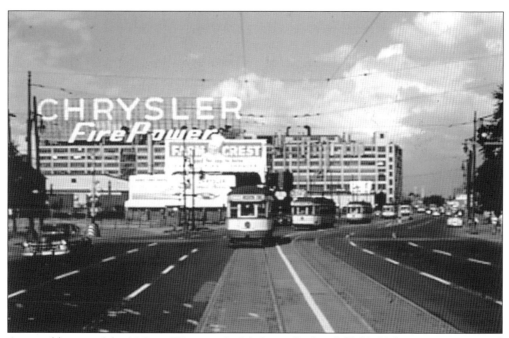

A partial lineup of the 12 Peter Witts on the Michigan Railroad Club's 90th anniversary special is shown here on Jefferson Avenue passing the Chrysler plant on August 16, 1953. (Richard Andrews collection.)

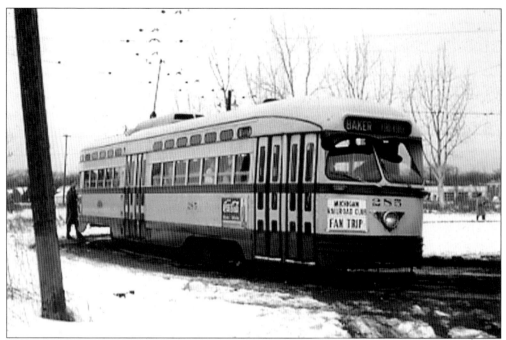

PCC 285 is photographed at the Gratiot Loop on a Michigan Railroad Club charter to commemorate the last day of DSR streetcar service on the Gratiot line on March 24, 1956. This was the loop that once served Eastwood Amusement park for many years. (Richard Andrews collection.)

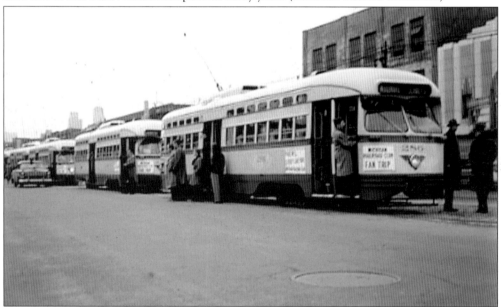

PCC 286, on Gratiot Avenue, is heading north from downtown on the last day of streetcar service on the Gratiot line, March 24, 1956. This would be just a couple of weeks before all streetcar service would come to an end in the Motor City, with the final trip occurring over the Woodward line on April 8, 1956. Of Detroit's 186 PCCs, 183 would be sold to the transit company in Mexico City where they would remain in revenue service for another 30 years. (Richard Andrews collection.)

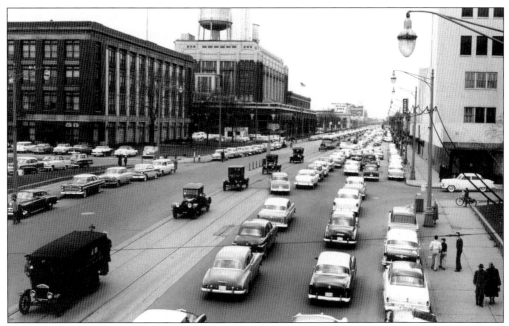

For the Last Day of Streetcars in Detroit parade, a vintage bus and automobiles led the DSR PCC streetcars. They are shown passing through Highland Park on their way to the Fairgrounds Loop on the last day of streetcar service on Woodward Avenue, April 8, 1956. One of the sponsors of this parade was the Michigan Railroad Club. (Schramm collection.)

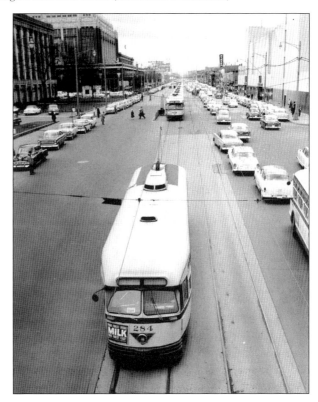

In the Last Day of Streetcars in Detroit parade, DSR PCC 284 passes through Highland Park; it is about to go under the Detroit Terminal Railroad overpass on its way to the fairgrounds loop on April 8, 1956. (Schramm collection.)

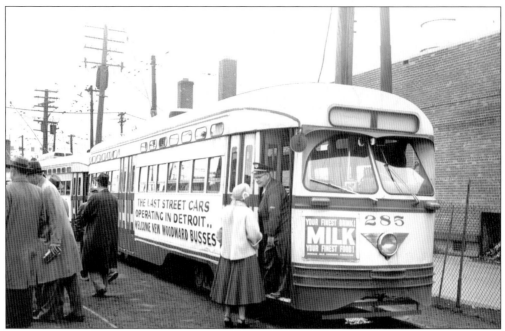

DSR PCC 285 is pictured at the Highland Park car house on the last day of streetcar service on Woodward Avenue in Detroit on April 8, 1956. (DSR files.)

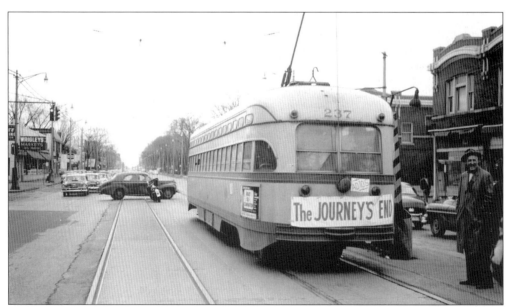

DSR PCC 237 was the last official DSR PCC to operate over the Woodward line on April 8, 1956. Eventually, 183 of the DSR's 186 PCC cars would be sold to Mexico City where they would remain in service for another 30 years. (Photograph by Richard Glaze.)

Five

EARLY DETROIT BUSES
1925–1945

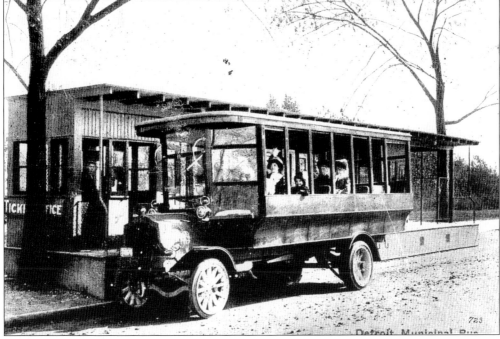

Detroit's large island park in the Detroit River, Belle Isle, had bus service beginning in 1909. It was initially operated by the City of Detroit's Department of Parks and Boulevards mainly for city employees; however, the public could also ride. The city issued books of tickets containing 50 tickets that cost 1¢ each. Open-sided Packard buses were usually used, except on busy days when trailers, pulled by power units that seated 65 passengers, were placed in service. This passenger shelter was located on the mainland at east Grand Boulevard and Jefferson Avenue. (Schramm collection.)

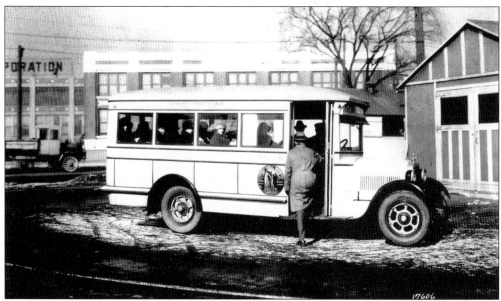

One of Detroit's first regular Dodge Graham–built coaches, or buses, is pictured; the terms were used interchangeably through the early years by the DSR and its employees. An early directive ordered the use of "coach" after establishing the Coach Division. A 5¢ fine was assessed for each offence for all employees caught using the term "bus." Here coach 51 appears at the Hart Loop on January 1, 1925, the first day of coach operations for the DSR. The voting booth at right in the photograph was used as a passenger shelter. (Schramm collection.)

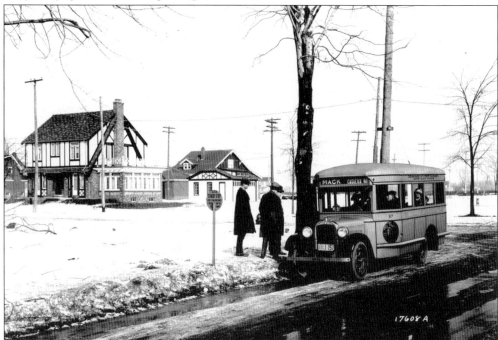

This DSR coach is heading east out Mack Avenue toward Cadieux Avenue on the first day of Mack Avenue bus service. The bus fare was 10¢ with a free transfer. The streetcar fare was 6¢ with a 1¢ transfer to other rail lines or 4¢ to another bus. (Schramm collection.)

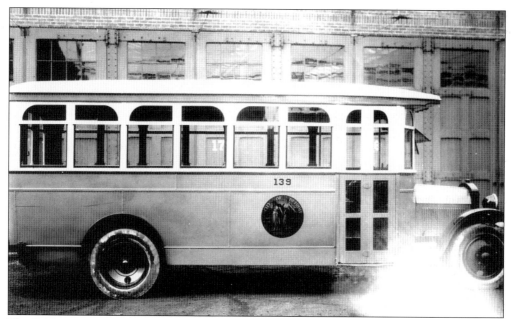

The DSR next purchased 12 Ransom Elgin Olds (REO) buses in 1925. This first order of REOs was numbered 151 and 152, followed by an order of 10 buses, numbered 131–140. The REOs were hard riding but able to operate on muddy, unimproved roads. Many suburban companies used them. REO bus 138 is shown here at the DSR's Highland Park shops. The DSR, by 1929, converted all 12 into service trucks. (Schramm collection.)

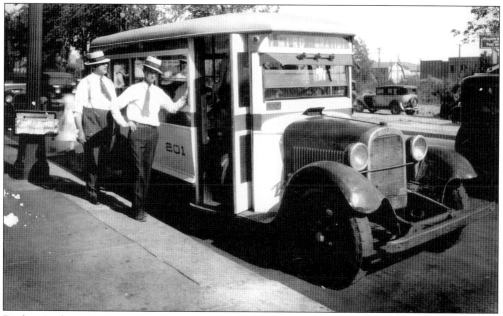

Dodge Graham–built coach 201 is at the end of the Seven Mile Road coach line at Woodward Avenue and Seven Mile Road. It must be a hot Detroit summer day, with the passengers wearing their straw hats. This model bus was built in 1926 and the photograph taken in 1931. (DSR files.)

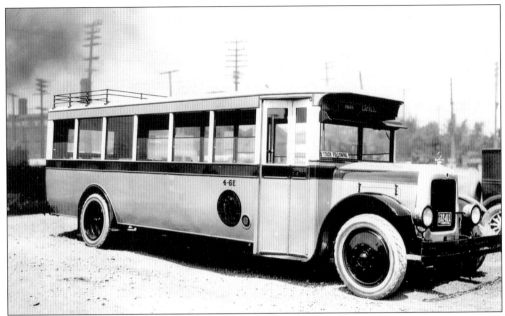

On March 10, 1925, the DUR went into receivership and offered to sell its express routes and 41 buses to the DSR. Shown here in 1926, immediately after the DSR's takeover of the People's Motor Coach (DUR) express bus lines is bus 4-6E, one of 23 of the model Yellow Coach Z-230. They were purchased by the DUR to operate express service from two outlying terminals to downtown Detroit. One route was from Oakwood Terminal just west of the Rouge River on Fort Street to downtown. The second route was from Gary Terminal on the east side at Gratiot and Connor, just across the street from Detroit City Airport. (Schramm collection.)

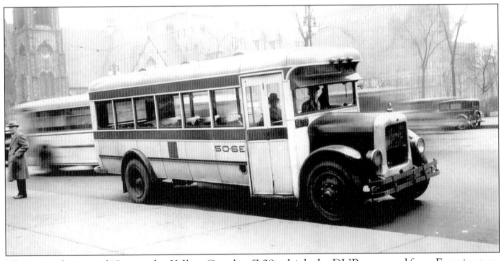

The second group of 18 were also Yellow Coaches Z-29, which the DUR operated from Farmington, Michigan, to downtown Detroit. Here bus 50-6E is sitting in downtown Detroit by Grand Circus Park, working the Jefferson Express route. Both groups were received July 1, 1926, and at first were operated by Peoples Motor Coach for the DSR until DSR drivers took over operations on November 1, 1926. The DSR operated busses to Farmington until 1928, when its Grand River streetcar line was extended to Farmington over DUR tracks. (Schramm collection.)

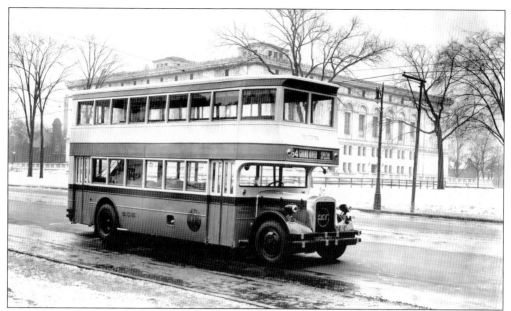

DSR Double Deck coach 506 is shown here traveling north along Woodward Avenue, passing the recently opened Main Branch of the Detroit Public Library. The American Car and Foundry (ACF) Model 519-4 gas-electric coach 506 was purchased by the DSR after they decided to operate with a one-man double-deck bus. The upper decks on all 50 buses were removed in 1929–1931. (DSR files.)

American Car and Foundry (ACF) No. 524 is an ex-double-deck bus, now reduced to single deck. According to a DSR shop record, there had been a problem with windows breaking on the upper deck of these buses. When the driver of one of the double-deck coaches had an upper deck damaged when he forgot that he was driving a double-deck coach, and as a result, all upper decks were removed during 1929–1931. (Schramm collection.)

DSR coach No. 511, built by American Car and Foundry (ACF) in 1927, seated 40 passengers. It was later renumbered twice, 601 and then 561. The photograph was probably taken at the ACF plant prior to delivery to the DSR. These ACF gas-electric buses were rider unfriendly. The engine revved up to high speed before the generator output was great enough to start, resulting in high vibrations, exhaust stench, and ear-splitting noise. The Hall-Scott gasoline engines used were soon called "all shot." (Schramm collection.)

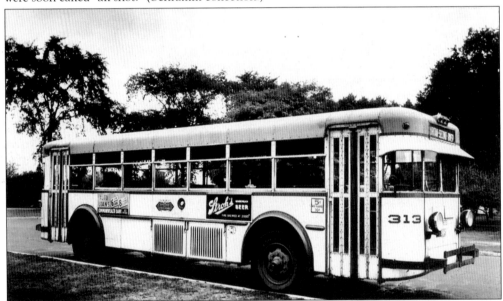

In 1929, a Twin Coach prototype visited Detroit, so the DSR held up purchasing buses until they could test a Twin Coach. A test was made of an ACF coach and a Twin; both were considered satisfactory. The DSR ordered 15 Twin Coaches, numbered 301–315, a Model 40 that seated 40, and also 40 ACF coaches, numbered 651–690. (Schramm collection.)

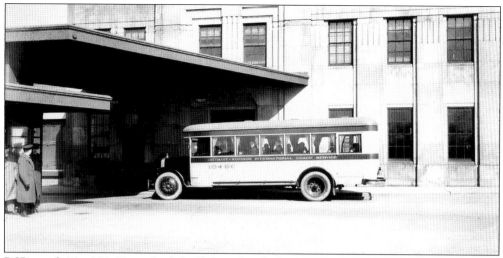

DSR coach No. 104-6E was built by Yellow Coach Company and the DSR. It was acquired by the DSR in 1929 and seated 29 passengers. Bus service began across the Ambassador Bridge between Windsor, Ontario (Canada), and Detroit on November 24, 1929. Originally, Windsor and Detroit would each furnish buses; however, Windsor was unable to do so. Therefore, the DSR provided all the buses used for this unique service. This included providing to Windsor, Yellow Coaches numbered 98–101. The DSR provided all buses cut down from ACF double-deckers: 504–506, 529, 542, 547, and 550 out of the DSR's Clark Street garage. Fares were 10¢ across the bridge and 25¢ from downtown to downtown. On January 3, 1931, Ontario Hydro dropped service to the United States. The DSR stopped operating to Canada on February 1, 1931, due to the opening of the Detroit-Windsor Tunnel, which operated its own fleet of Twin Coaches through the tunnel on a much more direct route. (Schramm collection.)

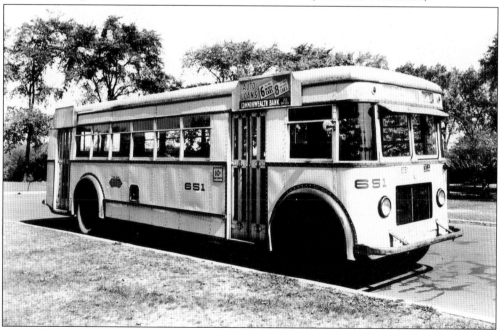

DSR coach 651, pictured in Palmer Park, was received in 1928–1929. This 40-passenger ACF gas-electric was part of an order of 40 coaches numbered 651–690. (Schramm collection.)

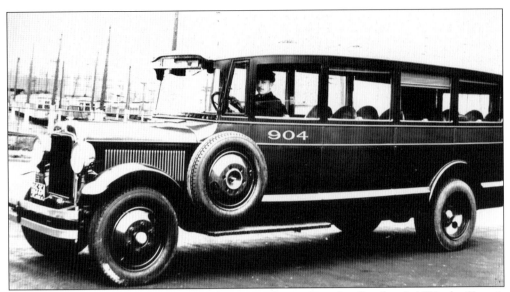

During the 1920s, the DSR fought to rid Detroit of its jitneys. On October 1, 1922, the Detroit City Council voted to prohibit jitneys operating on Fort Street, Grand River Avenue, Woodward, Gratiot, Jefferson, and Cass Avenues, John R. Street, and additional major downtown streets. The jitney operators obtained an injunction stopping enforcement. The fight lasted until October 28, 1928, when the Michigan State Supreme Court ruled in the city's favor. To provide replacement service for the jitneys, the DSR purchased 120 Graham Deluxe coaches, numbered 900–1019. (Schramm collection.)

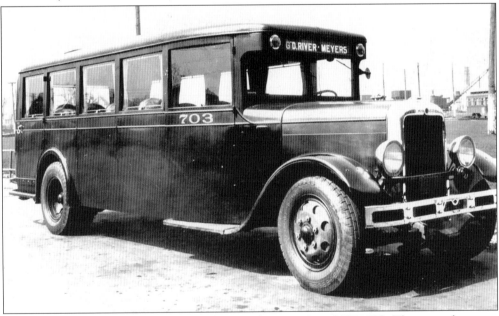

The DSR also purchased 40 Yellow Parlor Coaches, numbered 700–739. These coaches were assigned to the Grand River Deluxe line and ran there until 1937, when they were withdrawn and scrapped. Here coach No. 703 is pictured by the DSR's Coolidge car house. The extra-fare deluxe service ended on Woodward and Grand River Avenues in 1938, but the routes themselves kept operating at regular fares. (Schramm collection.)

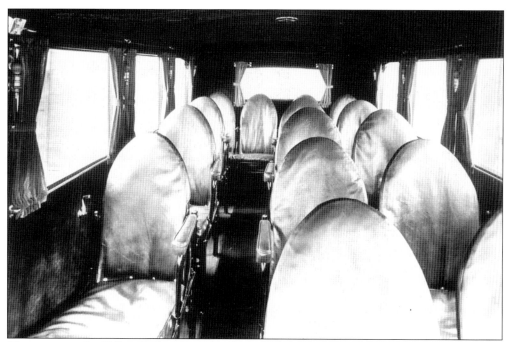

The interior of a Yellow Parlor Coach is shown. They seated 16 passengers with no standees allowed. These coaches last operated in 1936, replaced later by new Ford buses and charging regular fare. (Schramm collection.)

The DSR's Deluxe bus drivers were handpicked men in their late 20s. The drivers wore maroon-colored uniforms, not the usual blue-gray uniforms worn by the regular DSR drivers. These buses were also painted maroon, in contrast to the DSR's normal green and yellow paint scheme. Most of the Deluxe buses placed in service late in 1928 were Grahams. (Schramm collection.)

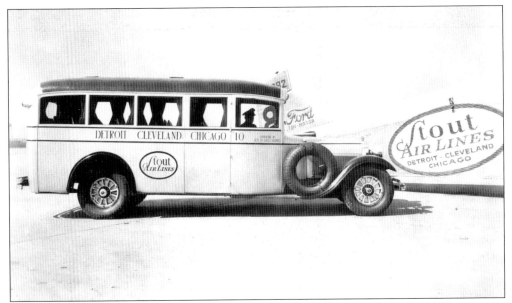

Coach No. 10 was a special-purpose coach built to DSR specifications that seated 15 passengers. One of just two Lincoln automobile chassis that were stretched and bodied by ACF in March 1930 for service to and from Ford Airport in Dearborn is pictured. Their interiors were designed to resemble those of the Ford Tri-Motors then being used by Stout Airlines. The coaches were allowed o park alongside the plane in order to speed up passenger transferring. (Schramm collection.)

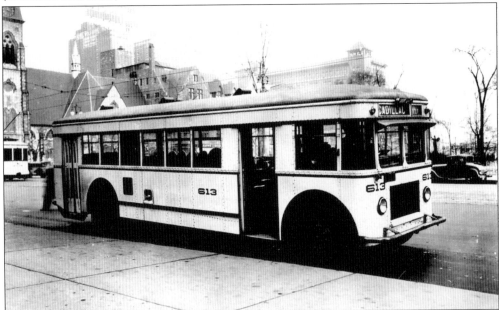

DSR coach 613 is laying over in downtown Detroit at Grand Circus Park. It was purchased during October and November 1930 as part of the last large buses built for the DSR by American Car and Foundry (ACF), numbered 601–650. The next large bus purchase was in 1945 following World War II, when 30 General Motors Corporation (GMC) 45 passenger buses were purchased, numbered 1001–1030. (Schramm collection.)

Detroit Motorbus Company 1002 was obtained in 1928 along with coach 1001. This picture of 1002 was taken still showing it in Detroit Motorbus Company colors. At this date, they were two-tone green and cream with a blue belt, orange wheels, and a light gray roof. All 32 of these buses were later purchased by the DSR and renumbered 319–350. (DSR files.)

Safeway Manufacturing Company made coach 437. This coach was originally owned and operated by Detroit Motorbus Company. It seated 27–29 passengers and was received by the DSR in 1932. The DSR did not renumber these Safeway coaches, 401–470, and only rented them a few years. (DSR files.)

A DSR open-air cruise coach is pictured. The DSR had 10 of these Twin cut-down coaches. Coach 325 is shown here with a gang of DSR employees from the DSR's Shoemaker Terminal. These coaches provided a two-hour evening tour around downtown Detroit and Belle Isle Park during the summer months. (DSR files.)

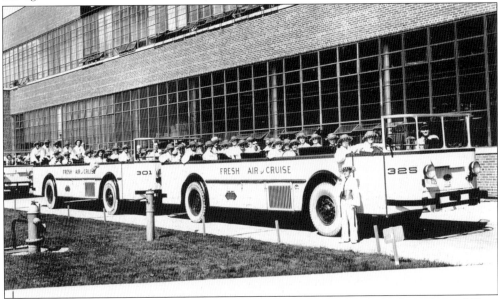

DSR coach No. 325 is on a charter next to the Dodge Company truck plant. Several Twin Coaches, after retirement, were cut down and used for charters or fresh-air evening cruises in the 1930s. The fare was 25¢ and included stops at Belle Isle, Rouge Park, Grosse Pointe, and other Detroit area attractions. Coach 325 had been a Detroit Motorbus Company coach and purchased by the DSR after the Detroit Motorbus Company was forced out of business. (Schramm collection.)

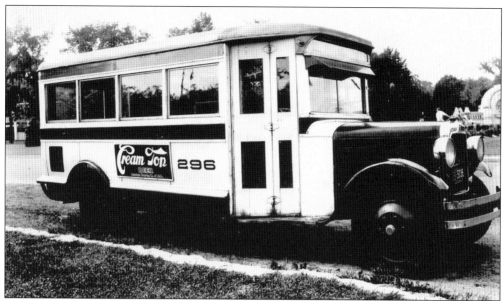

Coach 296 was a hybrid. Needing buses and having no funds to purchase them, the DSR attempted to rehabilitate some using chassis from the 1928 Deluxe Graham buses and bodies from the earlier Grahams. They rebuilt 36, which were numbered 264–299. Coach 296 consisted of a chassis from coach 944 and the body from coach 92. It is shown here in Palmer Park, just north of the DSR's Highland Park shops. The color scheme at that time was green and cream. (DSR files.)

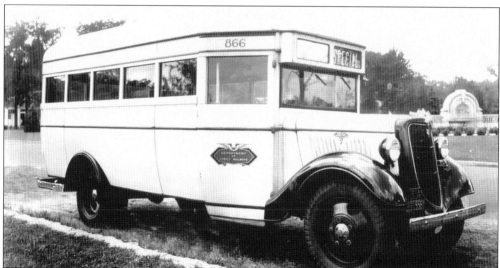

DSR's general manager, Fred Nolan, decided that he wanted to operate small coaches. The DSR Commission, after several meetings, decided on purchasing these small Ford buses. The problem with this bus was the limited headroom for passengers. Starting in April 1934, until July 2, 1935, the DSR ordered 332 of these small Fords. It also ordered 100 Chevrolet buses of the same design. However, not satisfied with the Chevrolet buses, it canceled the order after receiving just 15 and purchased the balance from Ford. Bus 866, shown here on Merrill Plaisance at Second Avenue, was part of a group received on January 7, 1935. The DSR's next move was to build its own bus. (DSR files.)

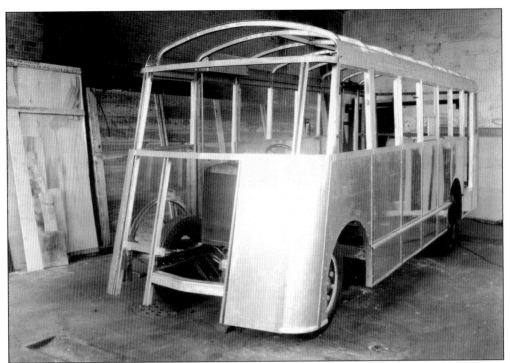

DSR coach 899 is pictured above left during construction in the DSR Highland Park shops. Built on a modified Ford conventional chassis and completed in April 1936, this was the only coach completely built by the DSR in its own shops in the 1930s. Other operators and independent shops were engaged in similar experimental work at about the same time, but it was the DSR's interest that encouraged Ford to design its own Transit bus, which was subsequently produced in large numbers. The 899 remained on the active roster and in active service until January 5, 1943, when it was rebuilt as a service truck. (DSR files.)

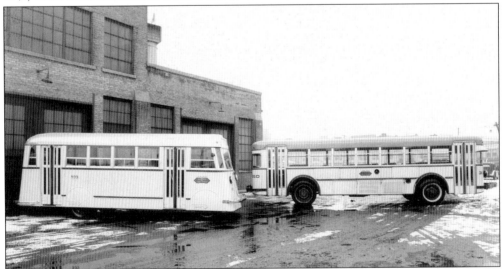

Coach 899 is shown outside of the DSR's Highland Park Shops with Twin Coach 310. This photograph provides a good comparison of the small size of this DSR designed coach. (DSR files.)

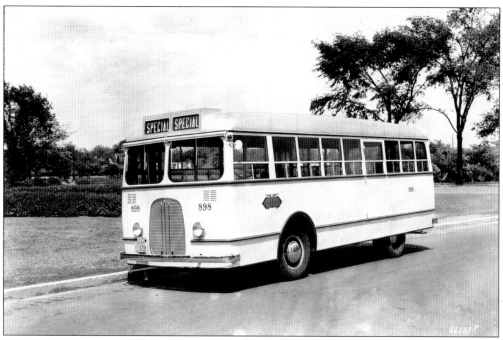

DSR Ford Transit coach 898 poses in this park-side setting in Detroit's Palmer Park. This was the prototype for Ford Transit buses that eventually led to the single-largest bus order ever placed with 500 Ford Transit buses being ordered by the DSR. (DSR files.)

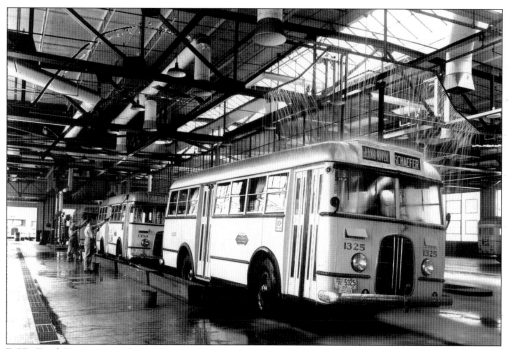

DSR Ford Transit coach 1325 is receiving a wash in the shop at Coolidge Terminal in 1939. These coaches were nicknamed the "white bottom" coaches because they were painted white along the bottom panel. (DSR files.)

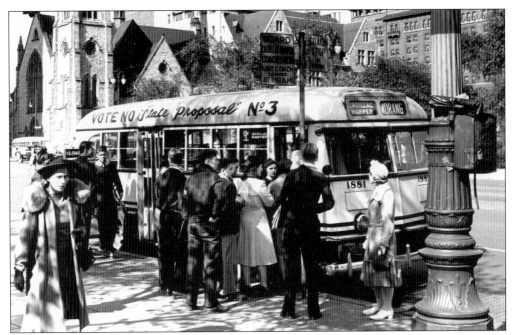

DSR Ford Transit coach 1881 loads a group of students in Grand Circus Park while on its way to the east side of Detroit. This coach is operating on the Cadillac-Harper coach line, which was originally started by the Detroit United Railway. (Schramm collection.)

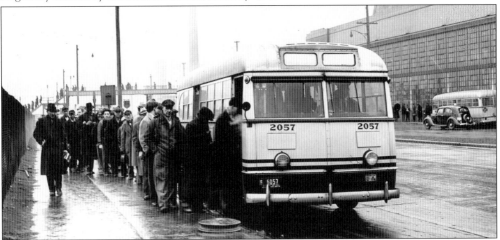

DSR's "black bottom" Ford Transit coach 2057 is loading next to the Ford plant on Miller Road in Dearborn. These small buses designed for feeder routes and smaller cities were overwhelmed by wartime loads. Drivers used the second gear for braking because of a lack of braking power resulting in high fuel consumption and engine wear. It is a change in shift, and workers are heading home. The pedestrian overpass visible in the background had been built to allow employees to cross Miller Road to and from the large off-street rail loops on the east side of the street. This was where the famous "battle of the overpass" took place during the 1937 United Automobile Workers strike to organize the Ford plant. From the time the plant reached full capacity in 1929, the Rouge was historically the DSR's single most important traffic generator. After the war, truck and bus production was moved from this plant back to Highland Park. (DSR files.)

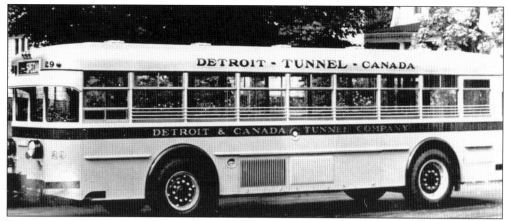

The Detroit-Windsor Tunnel opened on November 3, 1930. It provided its own bus service linking the two downtown areas of Windsor, Ontario, and Detroit through the new tunnel until February 1, 1982. It operated 15 Twin Model 40 coaches when it first started this new bus service, as shown here in this photograph. In 1982, when it was refused a fare increase, it dropped the bus service. This service is now provided by Transit Windsor. (Schramm collection.)

The Detroit-Windsor Tunnel Company operated its own buses through the tunnel that connects Detroit and Windsor for over 50 years. Here are two of its Twin Coaches passing at the international border in the tunnel. (Schramm collection.)

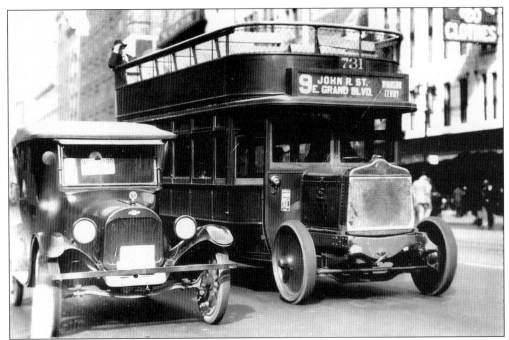

Detroit Motorbus Company bus 731 is headed south on Woodward Avenue for the Detroit-Windsor Ferry docks. Alongside is a Woodward Avenue jitney. It was not until the city purchased the Detroit United Railway city operations that the City of Detroit attempted to force the jitneys off Detroit streets. (Railway Negative Exchange.)

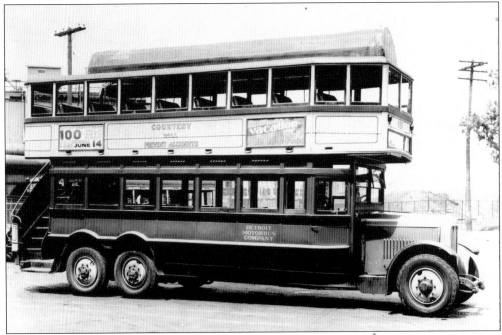

Detroit Motorbus Company double-deck bus 636 is pictured. This coach was built by the Six-Wheel Company. One company employee noted the only advantage of the wheel arrangement was "a passenger will hit the same bump twice." (DSR files.)

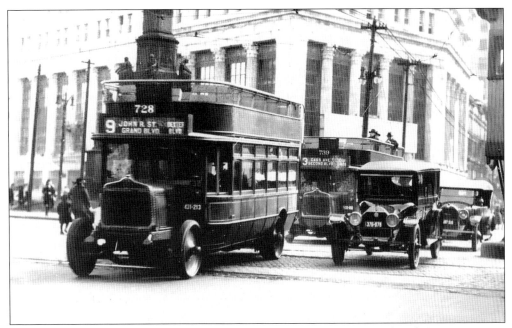

Detroit Motorbus Company double-deck buses are going north on Woodward Avenue, passing Detroit's National Bank Building and the Soldiers and Sailors Monument in the late 1920s. Bus No. 739 on route No. 3 will end at Six Mile Road and Livernois Avenue. Bus No. 728 on route No. 9 will end at John R. Street and Gerald Avenue in Highland Park. (Railway Negative Exchange.)

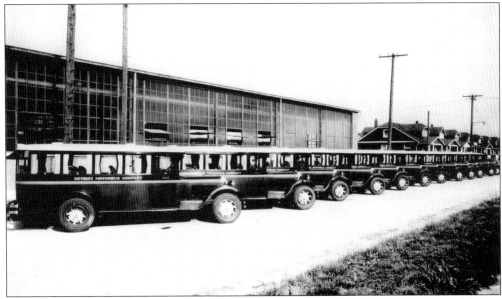

Detroit Motorbus Company (DMC) Studebaker-built buses with 12-passenger FitzJohn bodies line up at the bus garage on Hartwell Street in Dearborn in this August 1928 photograph. With Detroit Motorbus Company now operating into the surrounding suburbs, 24 of these 12-passenger Studebakers were purchased in 1928. By 1929, nine were enlarged to carry 21 passengers. When DMC was forced out of business, the DSR decided not to purchase any of these particular busses. (DSR files.)

In October 1939, the Federal Communication Commission granted the DSR permission to use an ultra-high frequency (UHF) channel using the call letters WALJ. The radio station was located on the top floor of the Barlum Tower in downtown Detroit. The DSR divided the city into 15 patrol districts. Each district had a service inspector with an automobile equipped with a two-way radio. These automobiles were called "Green Hornets." (DSR files.)

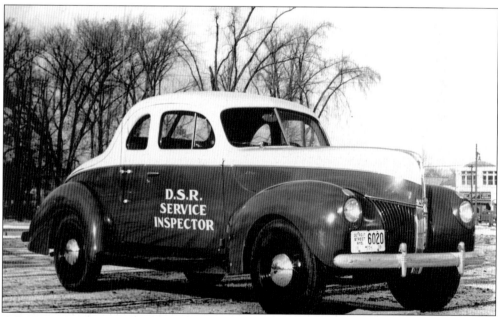

A DSR service inspector car, commonly referred to as the Green Hornet because of its colorful green and cream paint scheme, is shown here in this 1930s photograph. It featured some of the latest transit technology in providing services to the DSR's fleet of buses and streetcars, such as two-way radio. Note the special Department of Street Railways–issued license plate. (DSR files.)

Six

DETROIT TROLLEY COACHES

1921–1962

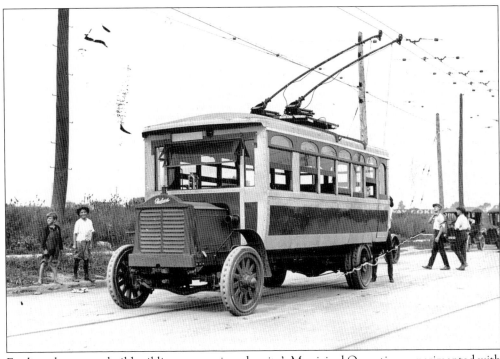

Finding the cost to build rail lines expensive, the city's Municipal Operation experimented with trolley coaches in 1921. The body of this DSR trolley coach was built by Brill, the chassis by Packard. The coach had two separate bases for the trolley poles, one 30 inches in front of and 10 inches above the other, and both rested on the longitudinal axis. It is shown here at Harper Avenue and Montclair Street. (DSR files.)

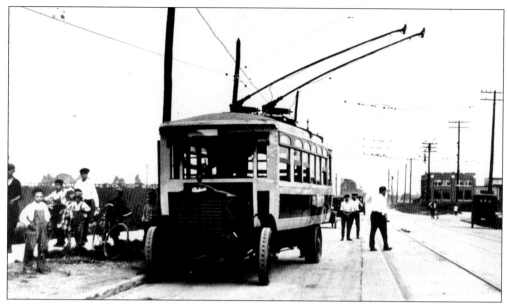

Shown here is the Packard trolley coach undergoing tests by the DSR at Harper Avenue and Montclair Street; the DSR is installing a second overhead wire paralleling the streetcar wire of the St. Jean line. Since many Detroit streets were unpaved, a short section of Pennsylvania Avenue was wired to test the trolley coaches on unpaved streets. The test was conducted from Warren to Charlevoix Avenues. Evidently they never obtained the ride quality they wanted and ended testing. (DSR files.)

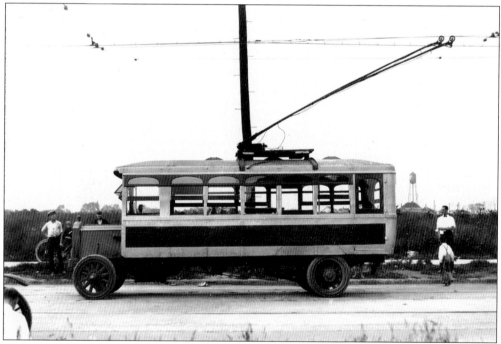

The second Packard trolley coach is pictured here; the body was built by Brill. A truck chassis was modified by Packard by installing two electric motors in place of a truck engine and transmission. (DSR files.)

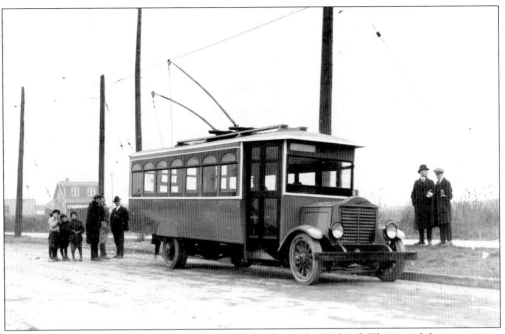

This trolley coach body was built by Kuhlman, the chassis by Packard. The initial demonstration of Detroit's trackless trolleys used four coaches. Besides the two Packard coaches, one of the other coach bodies was built by the St. Louis Car Company. This was the second Packard unit being tested at the same location on Harper Avenue. (DSR files.)

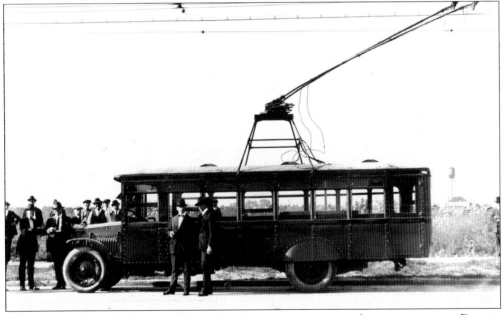

Pictured is the Standard Imperial Omnibus when it was operating for test purposes in Detroit. This trolley coach was built by the Trackless Transportation Company of America, a New York state company. The year was 1921, and the coach "competed" with a unit from Packard and St. Louis Car Company. Detroit did not adopt the trackless trolley coach at that time. The next test of trolley coaches by the DSR was not until 1924. (DSR files.)

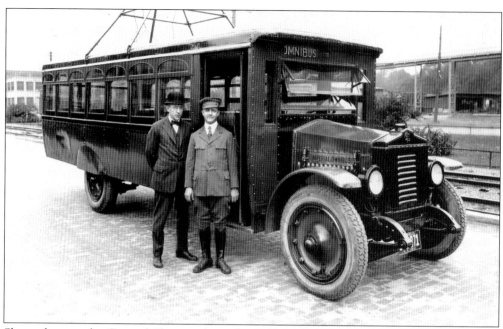

Shown here at the General Electric plant, this DSR trolley coach was built by the Trackless Transportation Company of New York in 1921. The chassis was known as the Standard Imperial Omnibus. The DSR tested this trolley coach on Harper Avenue in 1921. This same type of trolley coach was also used in Windsor, Ontario, Canada. (Tom Dworman collection.)

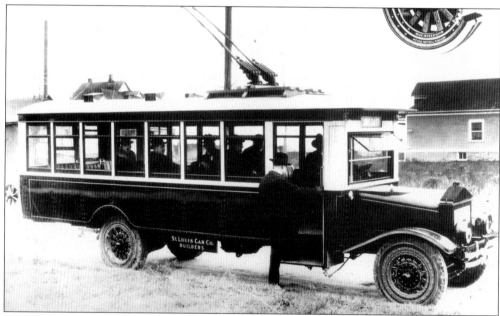

This DSR trolley coach was built by the St. Louis Car Company for testing in 1921. The St. Louis Car Company built its first trackless trolley with artillery wheels and solid tires. The trolley coach shown here has the Sewell Cushion Wheel, which was used in Detroit. However, they were still very hard riding. An example of one of these type wheels is illustrated in the inset. (DSR files.)

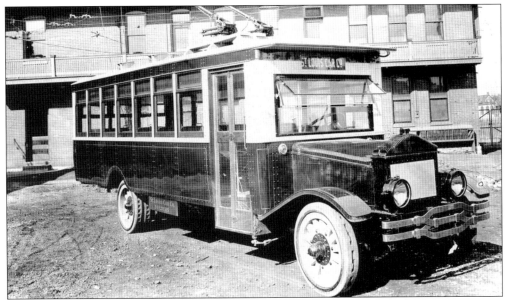

This DSR trolley coach was built by the St. Louis Car Company and tested in Detroit in November 1921. This and the two Packard trolley coaches with their hard rubber tires were not accepted; the ride was too hard for the passengers. Mayor James Couzens in a December 16, 1921, letter to J. S. Goodwin, general manager of the DSR, commented on the rough ride. He suggested pneumatic tires be obtained even at their higher prices and also to determine the additional cost per mile to operate. (Tom Dworman collection.)

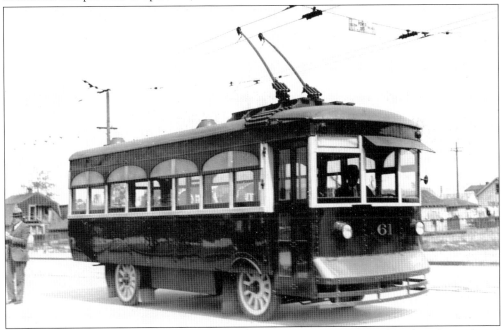

This Brill "Railess Car," built by Brill Manufacturing Company, was tested by the DSR and used for a short period of time in 1924 to try out trolley coach service on Warren Avenue between Cadillac Boulevard and St. Jean Avenue. This trolley coach eventually ended up on the Oregon Avenue trolley coach line in Philadelphia, Pennsylvania. (DSR files.)

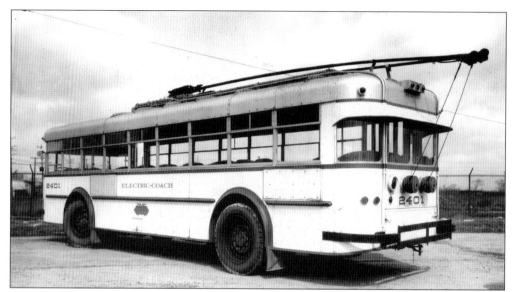

Twin Trolley Coach 2401 was used on Plymouth Road. DSR general manager Del Smith had planned to operate several trolley coach routes. On June 14, 1930, the five-mile-long Plymouth Road line from Grand River to Rouge Park began, using six Twin trolley coaches. They were later renumbered in 1935 to the 2400 series to accommodate numbers for the new Ford Transit coaches being delivered to the DSR. Shown here in 1937, No. 2401 is awaiting sale at Coolidge Terminal after the end of trolley coach service on Plymouth Road. All six trolley coaches were sold to the Cincinnati Street Railway Company in 1942. The Plymouth Road Trolley Coach line usefulness ended when the line was extended several miles eastward to be merged with the Caniff coach line to form a 20-mile-long east-west crosstown line, all for a 5¢ fare. (DSR files.)

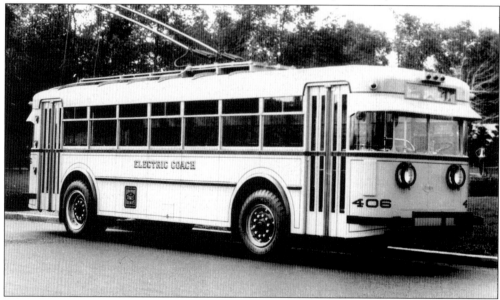

This front view of Twin trolley coach 406 on Plymouth Road was taken in May 1930. These 40-seat coaches were built in 1930 and were equipped with two Westinghouse 1426 motors. These coaches were 30 feet long and weighed 17,500 pounds. In 1935, they were renumbered 2401–2406. (DSR files.)

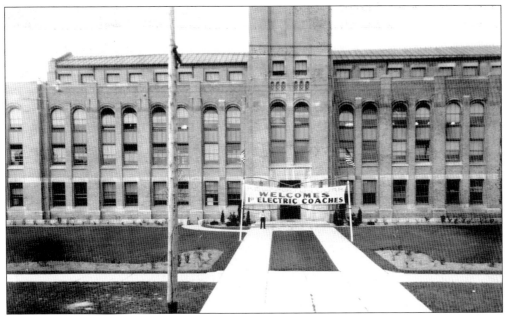

The Kelvinator Corporation plant on Plymouth Road eagerly welcomed the DSR's new trolley coach operation, proudly displaying a "Welcome Electric Coaches" banner across the front of its office building. This building later housed the headquarters of American Motors and is still standing today, fully utilized by the Daimler-Chrysler Corporation for its Jeep engineering offices. (DSR files.)

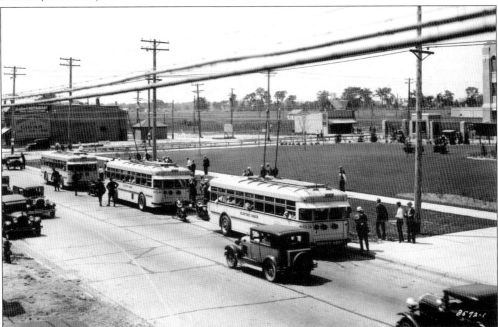

DSR trolley coaches line up in front of the Kelvinator Corporation plant on Plymouth Road on Detroit's west side. This is probably opening day of trolley bus service, and the general public are allowed to view them. Whether there were free rides given that day was not recorded. (DSR files.)

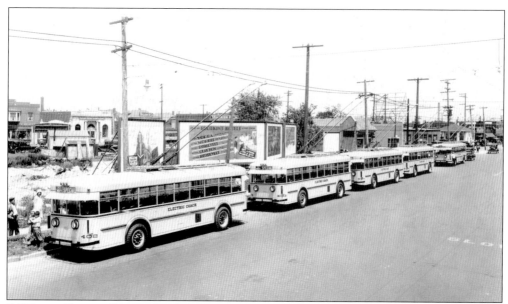

DSR's new Twin trolley coaches line up along Plymouth Road on opening day of the Plymouth "Electric Coach" line, June 14, 1930. Intended as the first of a network of trolley coach routes on the northwest side, Plymouth became the only one, as the Depression stalled the DSR's improvement program. Renumbered 2401–2406 in 1935, to make room in the roster for Fords, the six Twins ran on Plymouth Road until August 8, 1937, and were then later sold to the Cincinnati Street Railway Company in 1942. (DSR files.)

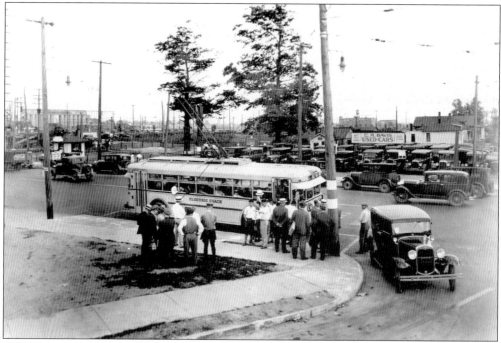

DSR Twin trolley coach 406 is in service on the Plymouth line at the Grand River Avenue end of the route. The Plymouth Road area of Detroit was expanding rapidly with many new homes being built. (DSR files.)

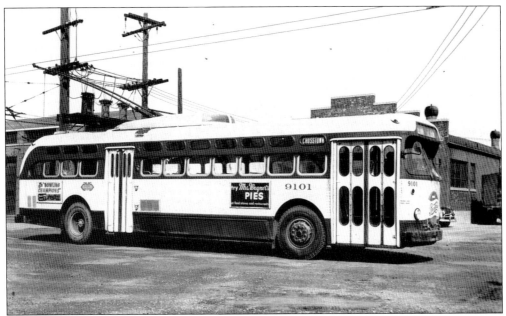

St. Louis Car Company–built trolley coach 9101 is pictured at the DSR's Coolidge Terminal. These 48-seat coaches were built in 1951 for the DSR's Grand River line. They were equipped with General Electric 1213 motors. These coaches were 39 feet long, 8 feet 6 inches wide, and they weighed 20,165 pounds. Two of these coaches were equipped with Westinghouse 1413 motors. The DSR had 80 of these type trolley coaches, numbered 9101–9180. (DSR files.)

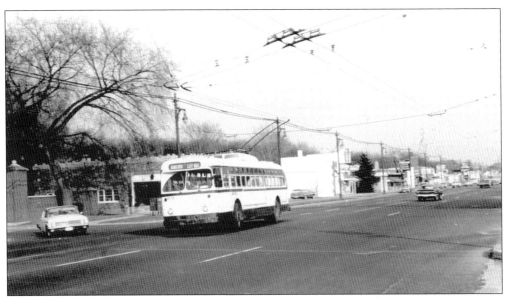

DSR trolley coach 9179 is inbound on Grand River Avenue at Puritan Avenue and Evergreen Road in November 1961. The last trolley coach operated on the Grand River line on November 16, 1962. Interesting to note, is that at the Grand River and Warren intersection, where both the Grand River and Crosstown trolley coach lines crossed, the overhead wires intersected with a "two-across-two" wire configuration and no connecting wires between the two trolley lines. (Photograph by James Alain.)

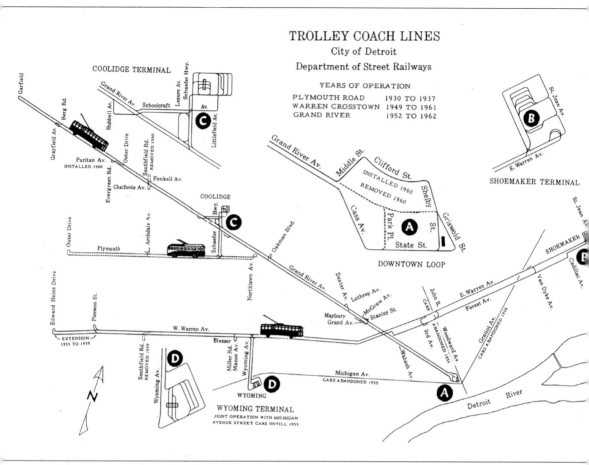

TROLLEY COACH LINES
City of Detroit
Department of Street Railways

YEARS OF OPERATION

PLYMOUTH ROAD 1930 TO 1937
WARREN CROSSTOWN 1949 TO 1961
GRAND RIVER 1952 TO 1962

COOLIDGE TERMINAL

SHOEMAKER TERMINAL

COOLIDGE

DOWNTOWN LOOP

WYOMING TERMINAL
JOINT OPERATION WITH MICHIGAN
AVENUE STREET CARS UNTILL 1955

Detroit River

This map provides a detailed look at the two distinct eras of Detroit's trolley coaches starting with Plymouth Road in 1930 through 1936. This was followed by the second era, when trolley coaches were introduced on the Crosstown line along Warren Avenue in 1949 and the Grand River line in 1952. All trolley coach services were discontinued by 1962. The electrical overhead that comprised these three trolley coach lines is shown in detail, including the connecting overhead to the three DSR trolley coach-based terminals.

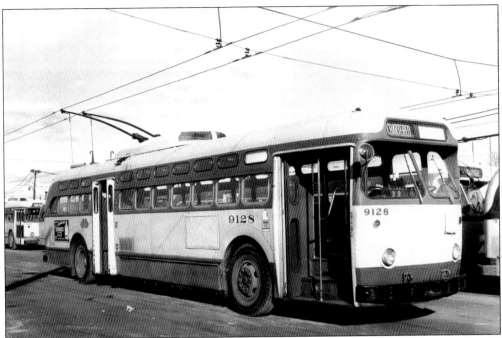

This DSR St. Louis Car Company–built trolley coach was used on the Grand River line. Shown here is trolley coach 9128 in the DSR's west side yard, Coolidge Terminal. When trolley coach service began on Grand River in 1951, Detroit Edison had no synchronous converters for its Redford substation, used to power the overhead trolley lines. Fortunately the city's Public Lighting Commission was able to supply one, and trolley service started on schedule. (DSR files.)

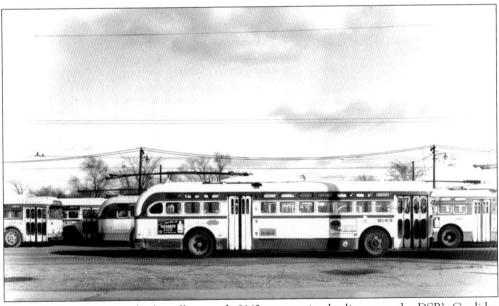

St. Louis Car Company–built trolley coach 9143 appears in the lineup at the DSR's Coolidge Terminal. These trolley coaches operated exclusively on the Grand River line until the end of trolley coach service on November 16, 1962. (Photograph by Richard Fountain.)

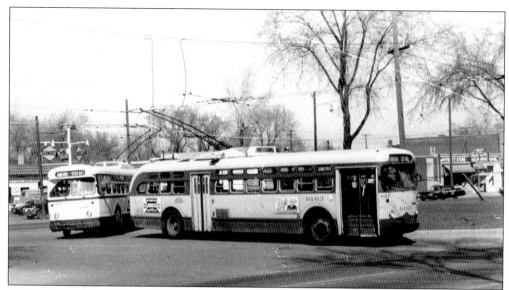

DSR trolley coach 9163 and 9129 are pictured at Grand River Avenue at Garfield Avenue. This loop was located in Redford Township, just north of Seven Mile Road. The trolley coaches were forced to use a new loop at this location because the former loop, located just south of Seven Mile Road and used by the Grand River streetcars, was no longer available. These trolley coaches are making the turn into the loop and heading back downtown in this April 1961 photograph. (Photograph by James Alain.)

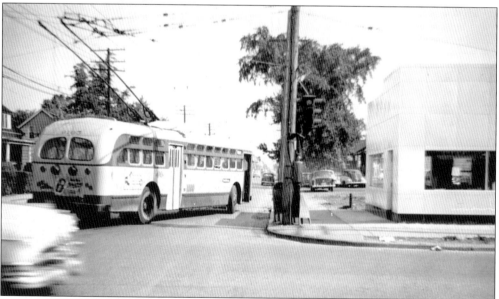

DSR trolley coach 9103 has just completed its run on the Grand River line and is turning north on to Schaefer Highway and Schoolcraft Avenue from Schoolcraft heading for the Coolidge Terminal in this June 1953 photograph. Originally the Grand River streetcar line was powered from four City of Detroit Public Lighting Commission substations and one Detroit Edison substation. When trolley bus service was planned for Grand River, Detroit Edison had scrapped their direct current (D.C.) power supply, and the Public Lighting Commission had to supply one to be installed in its Redford substation. (DSR files.)

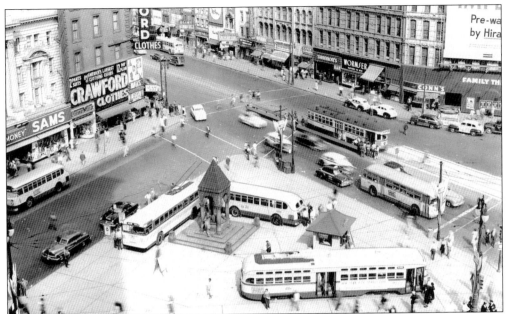

DSR equipment is displayed at Cadillac Square along with the new Twin trolley coach. The week of September 12, 1949, was National Transit Progress Week, and the DSR showed that it was making progress by displaying a new PCC car, a Twin Coach trackless trolley, and a Transit bus on Campus Martius. All of this new equipment was gone from the streets of Detroit by 1962. (DSR files.)

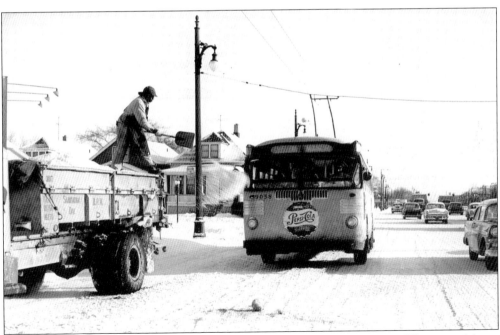

A Twin trolley coach on the Crosstown line travels eastbound on West Warren at Manor Avenue on a cold winter's day. Note the effort to keep the trolley route free of snow and ice as salt is being dispensed by the DSR's maintenance crew. (DSR files.)

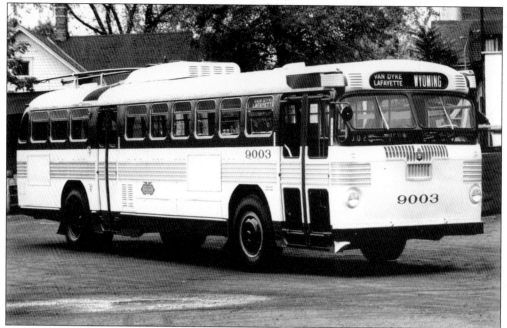

These 48-seat trolley coaches were built by Twin Coach in 1949 and were equipped with General Electric 1213 motors. These coaches were 38 feet 3 inches long, 8 feet 6 inches wide and weighed 19,000 pounds. This is coach 9003. The DSR had 60 Twin trolley coaches, numbered 9001–9060. (DSR files.)

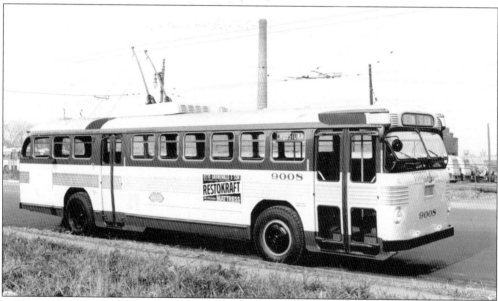

DSR Twin trolley coach 9008 is pictured on Warren Avenue right across the street from the DSR's Shoemaker Terminal. It looks as if this photograph was taken shortly after it was delivered to the DSR and put into service on the Crosstown line. The Twin trolleys were used exclusively on the Crosstown line, being based at Shoemaker (east side) and Wyoming (west side) Terminals. The last trolley coach operated on Crosstown on March 31, 1961, and the Grand River line on November 16, 1962. (DSR files.)